Copyright © 2017 by MIDEJA, Publishing LLC. All rights reserved. No part of this hand drawn coloring book may be reproduced in any form without permission in writing from MIDEJA, Publishing LLC.

Printed in the United States of America First Printing: January 2017 MIDEJA, Publishing LLC.

Index

Afros
Bald & Beautiful
Bangs
Bantu Knots
Big Chop
Braids
Buns
Chopped Bangs
Cornrolls
Curly Hair
Damaged Hair
Dreadlocks
Dreads with Bangs
Egyptian
Flowers in Hair
Giant hair
Headbands
Headwrap
High Top
Hijab
Indie
Jewelry in Hair

Indie
Jewelry in Hair
Kings
Kinky Hair
Long Hair
Mowhawk
Natural Hair
Oils
Pompadour
Ponytails
Princesses
Queens
Ribbons in Hair
Short hair
Straight Hair
Thick Hair
Twist
Twist - Out
Updos
Versatility
Wavy
X Gen Hair
Y Gen Hair
Zig Zags

Specials***

Aaliyah
Beyonce
Amy Winehouse
Dorothy Dandrige
John Lennon

Michael Jackson
Prince
Rihanna
Robin Williams
Selena
An Artist Named Lora Reina

An Achiever named Tiarah Poyao
An Author Named Loree Quinn
A Designer named Tonika
An Entreprenuer Named Brooklyn
A Hardworker named Janay
A missing Girl Named
Relisha Rudd
Black Proud & Unapologetic

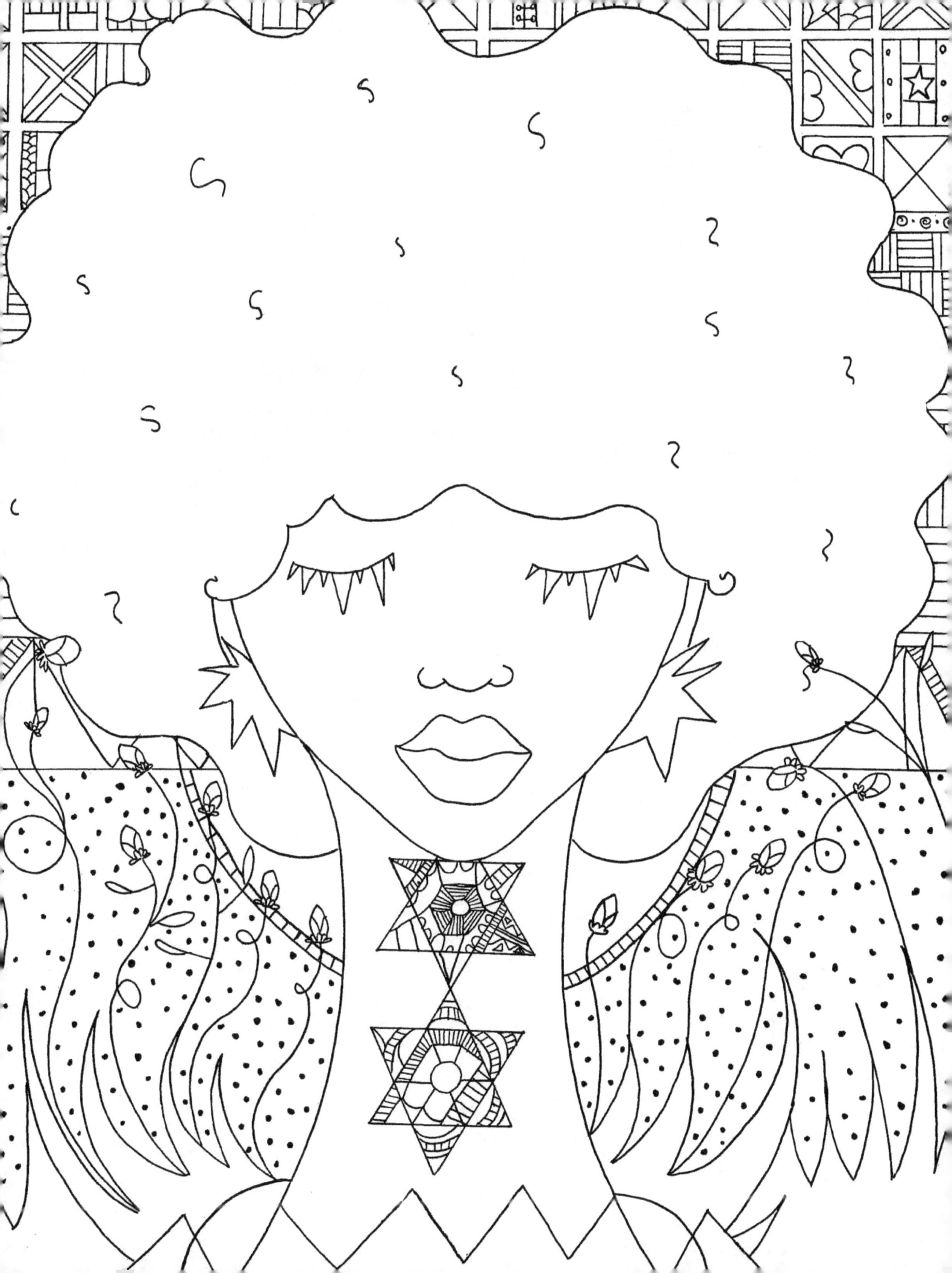

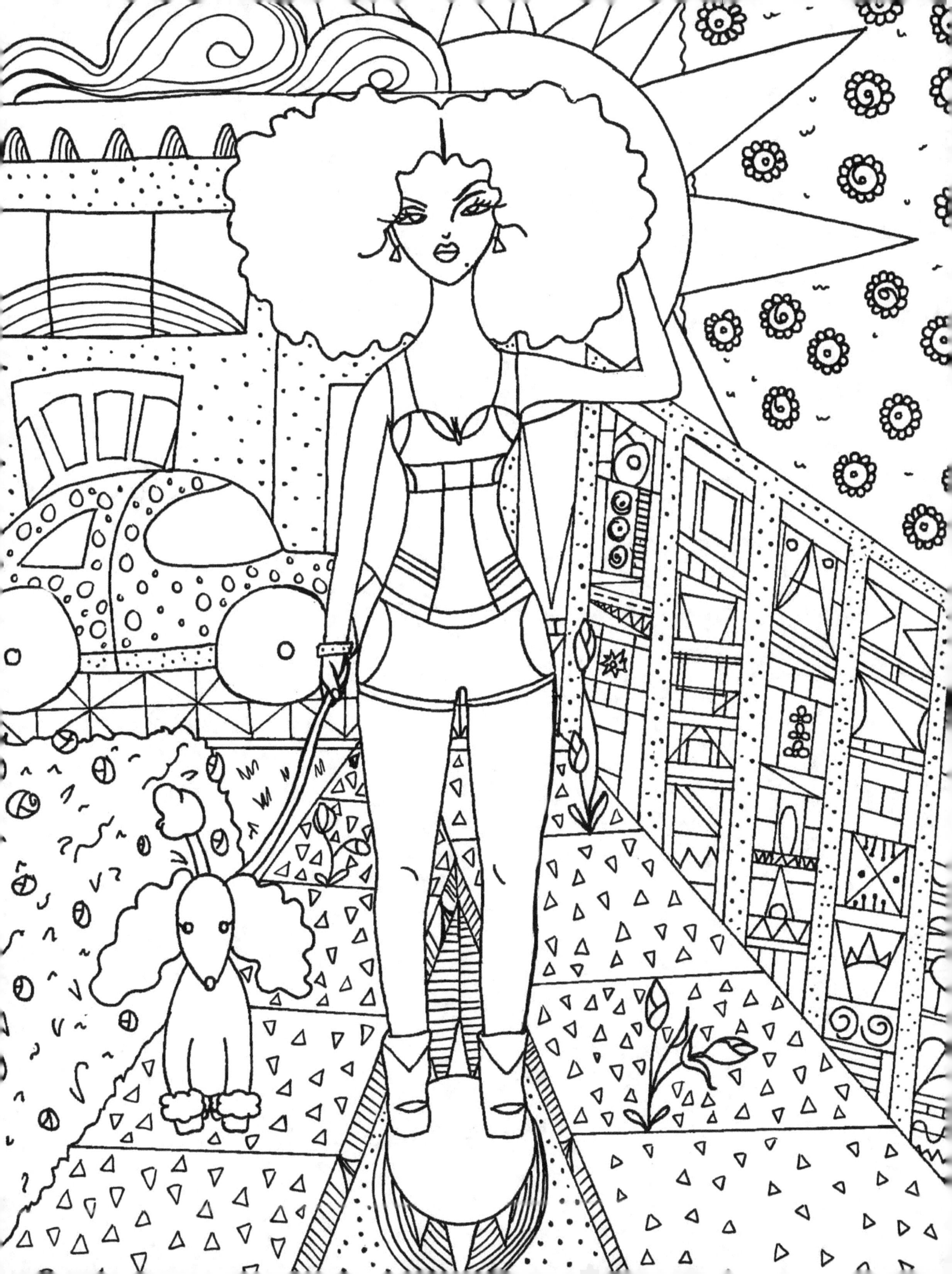

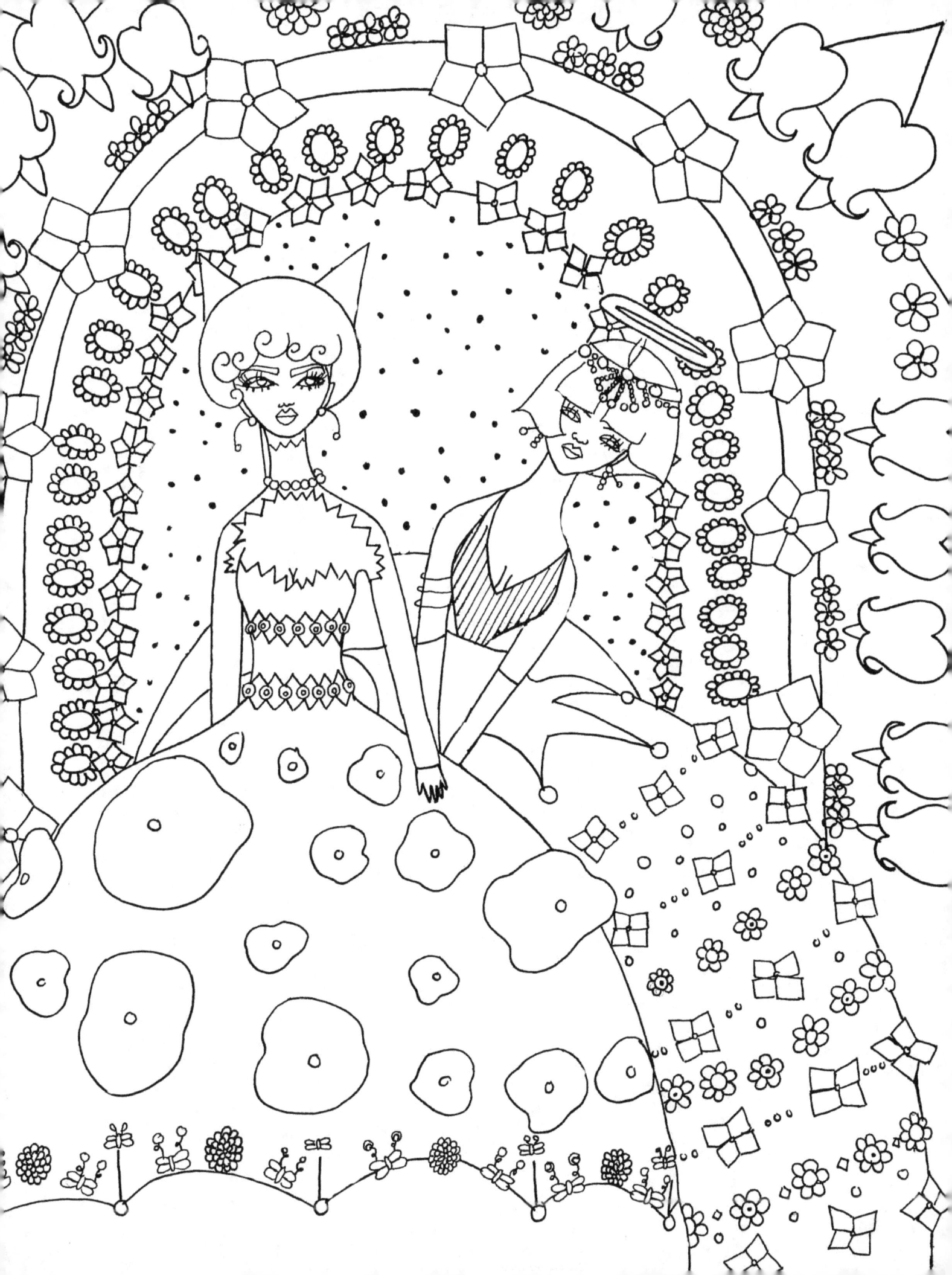

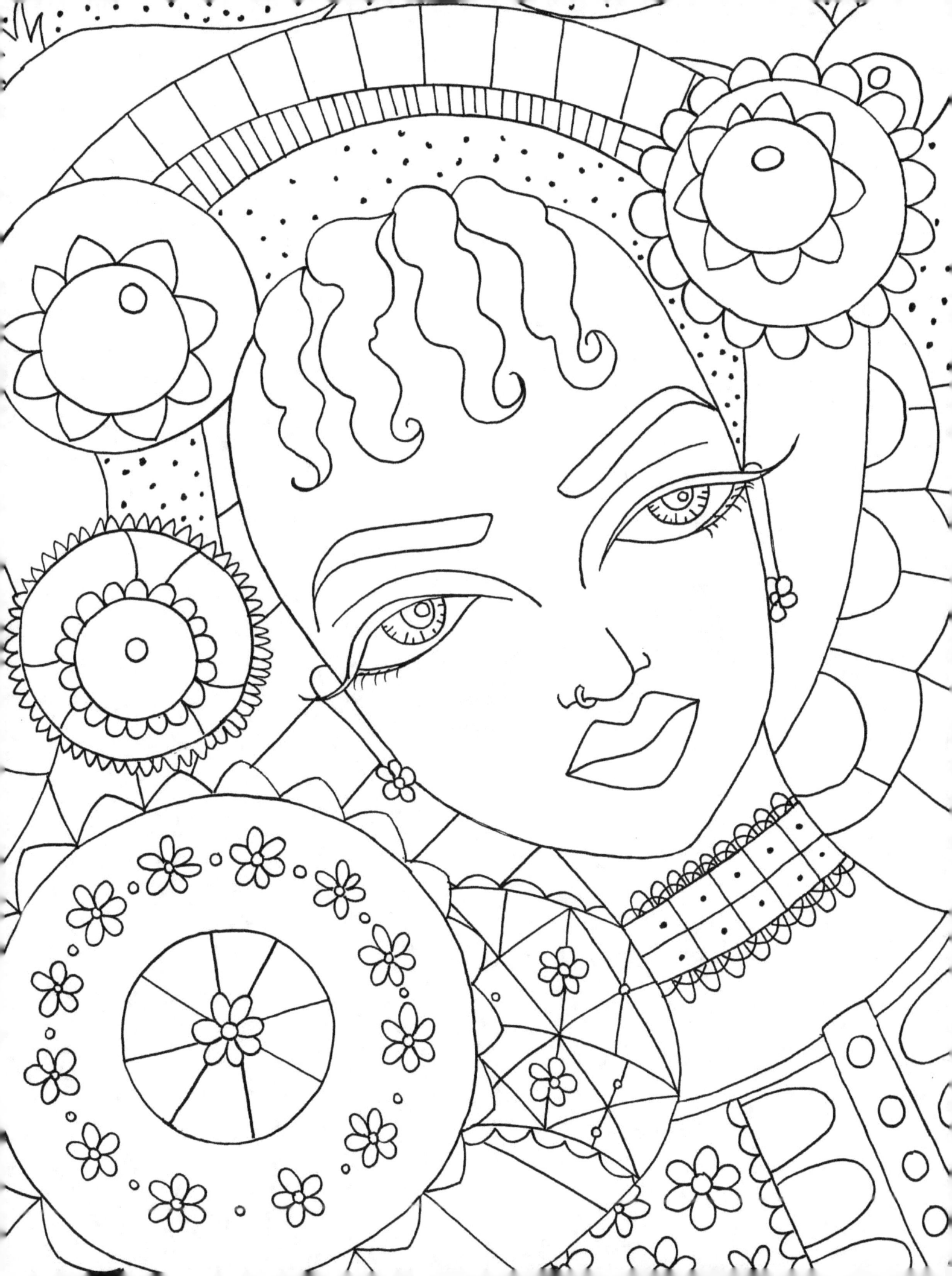

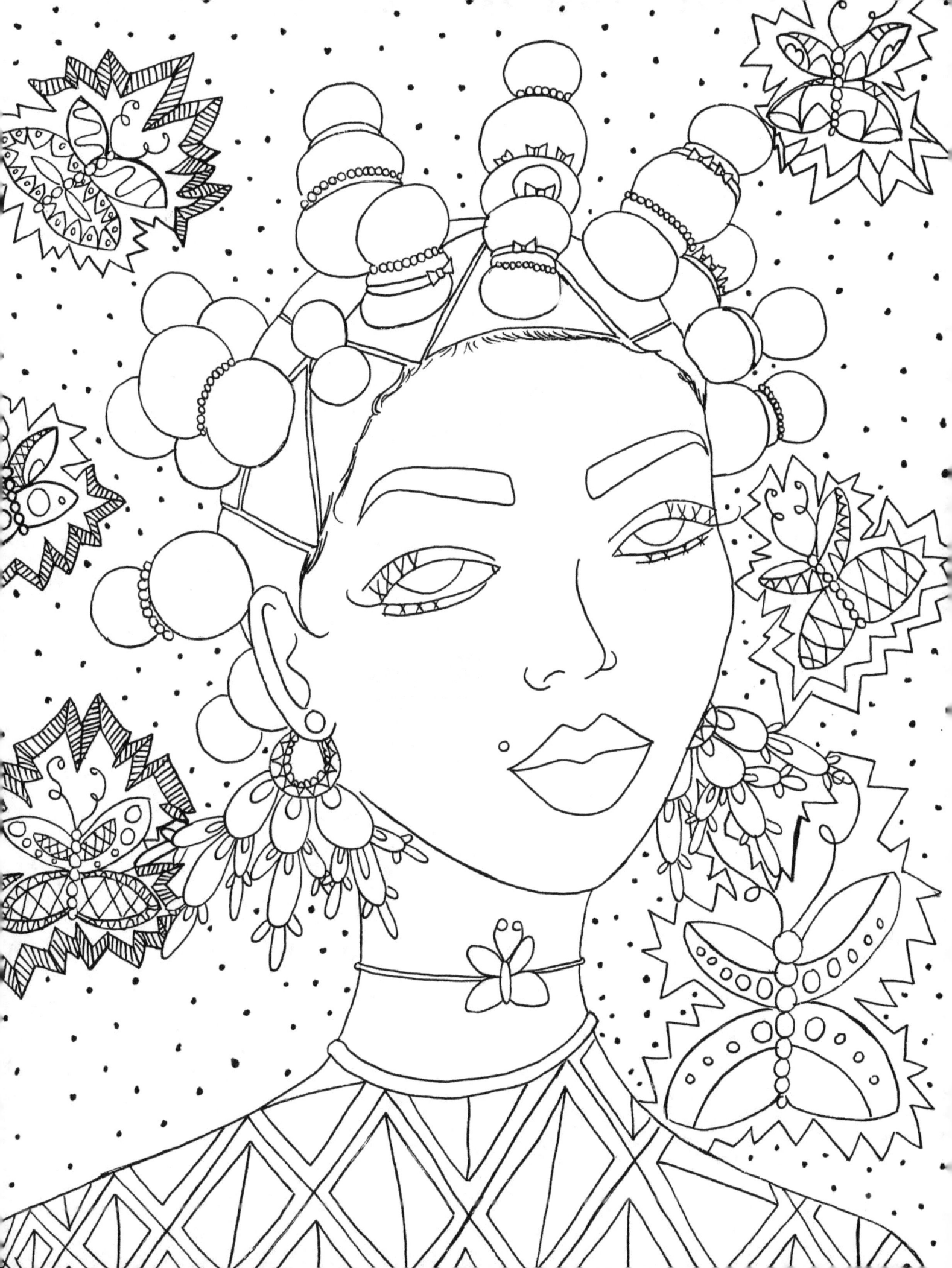

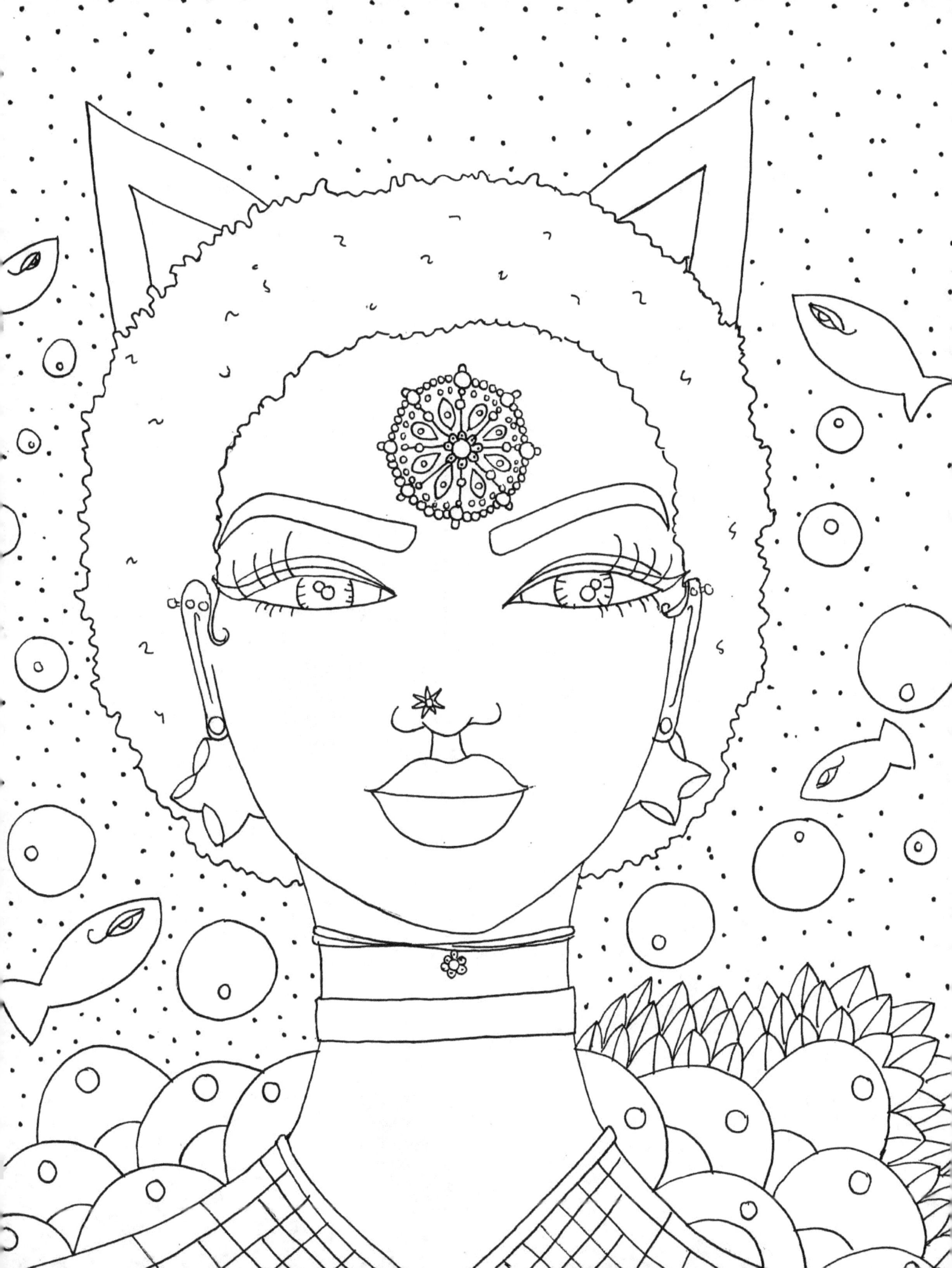

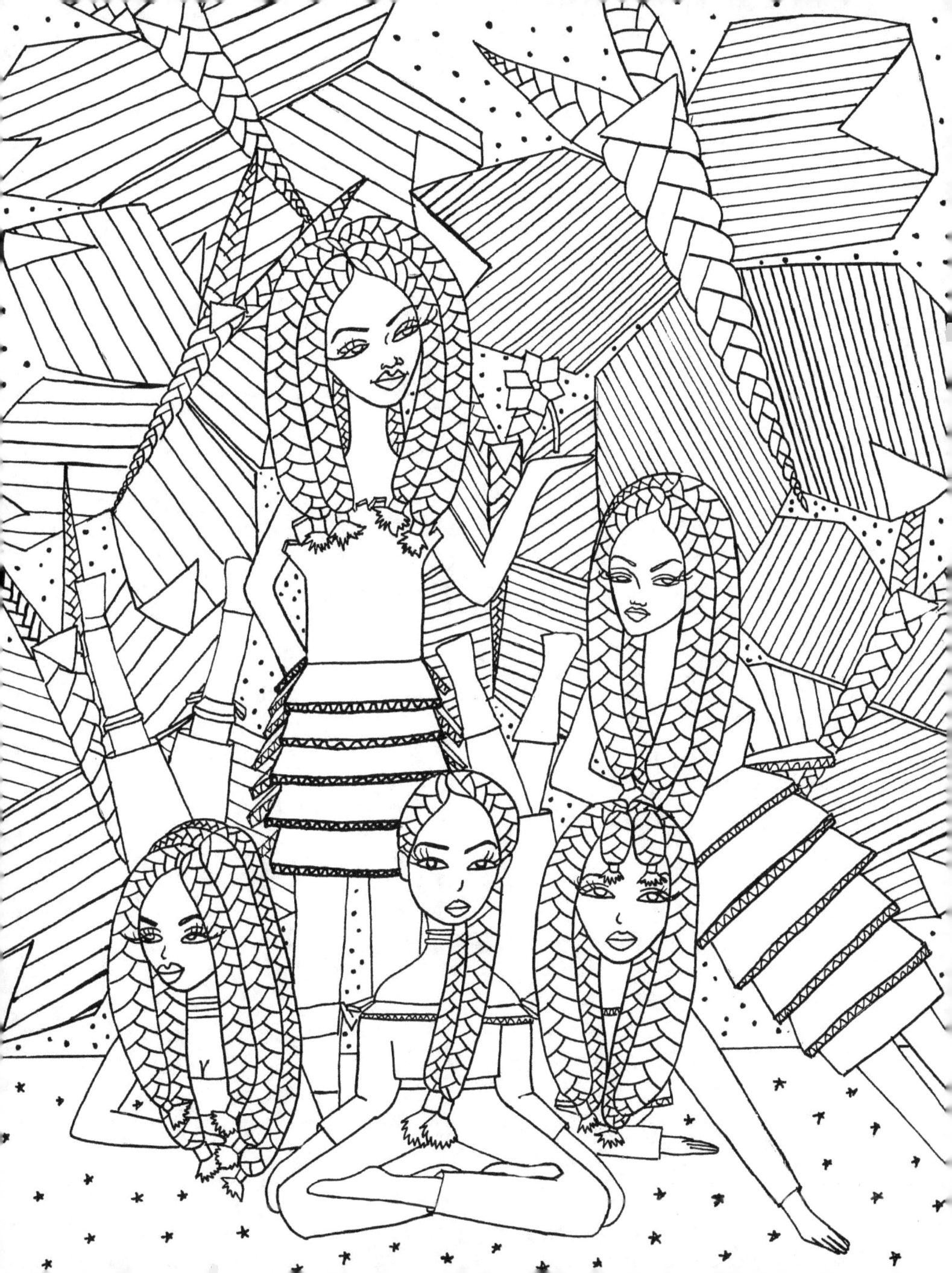

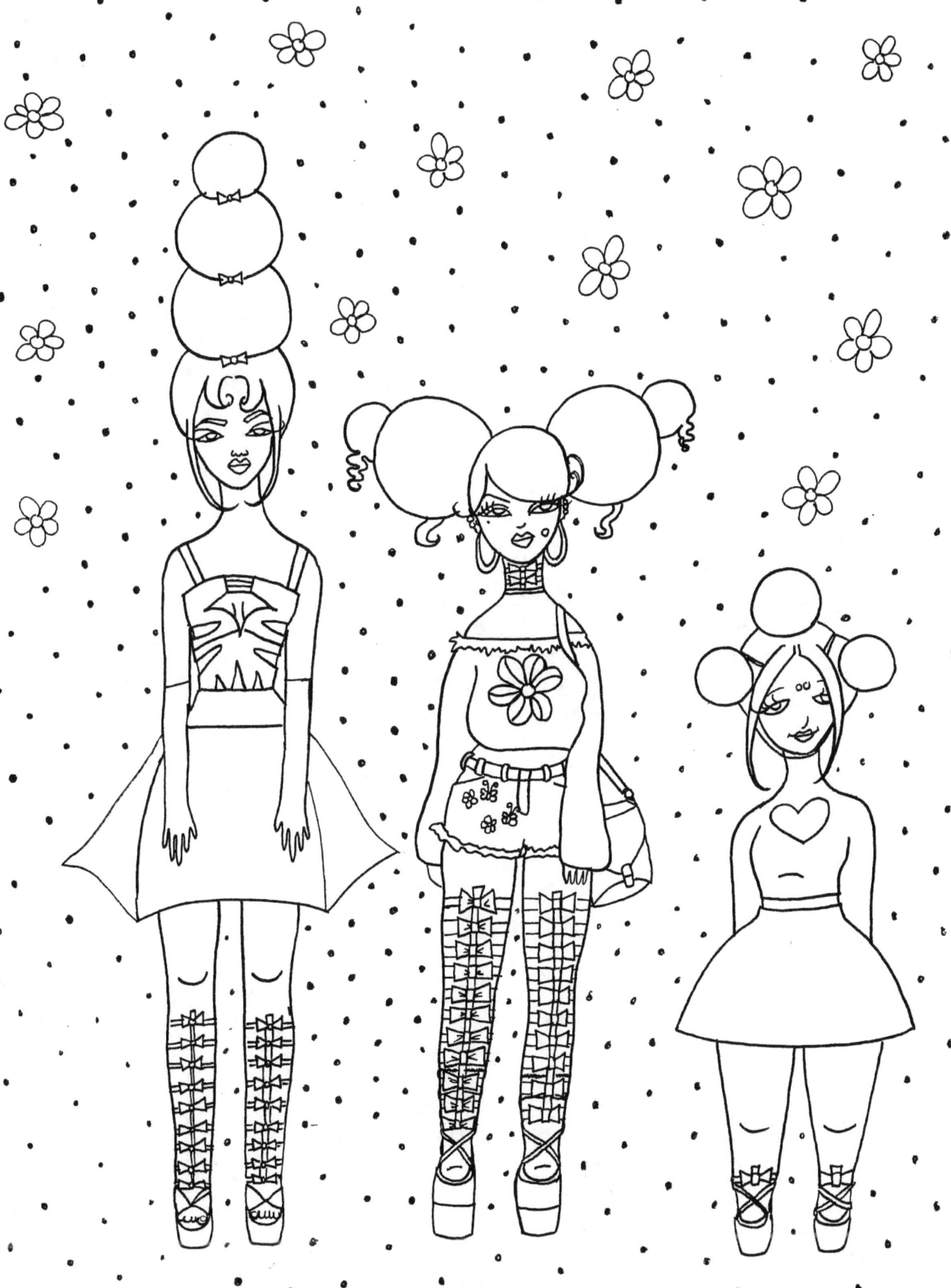

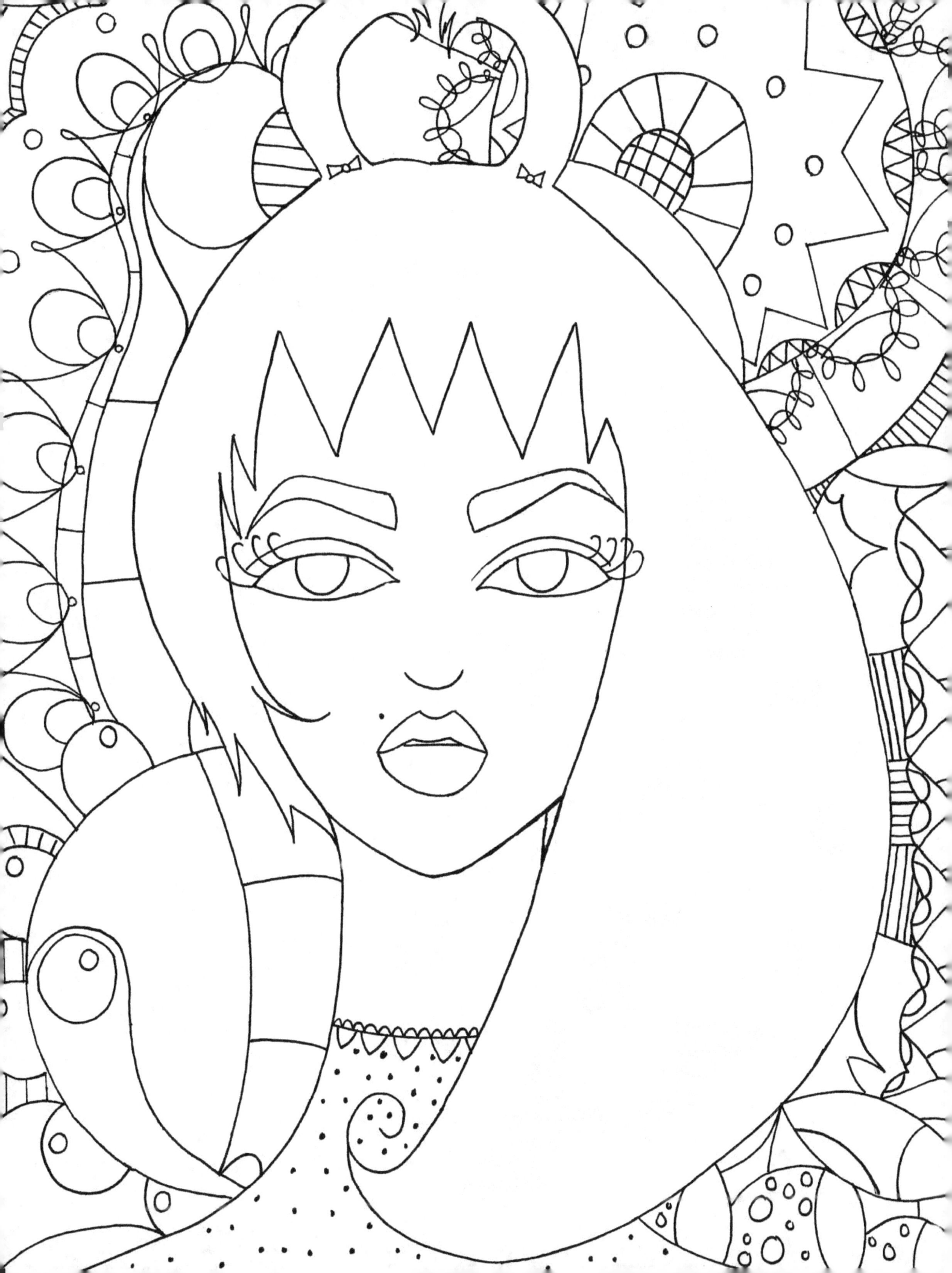

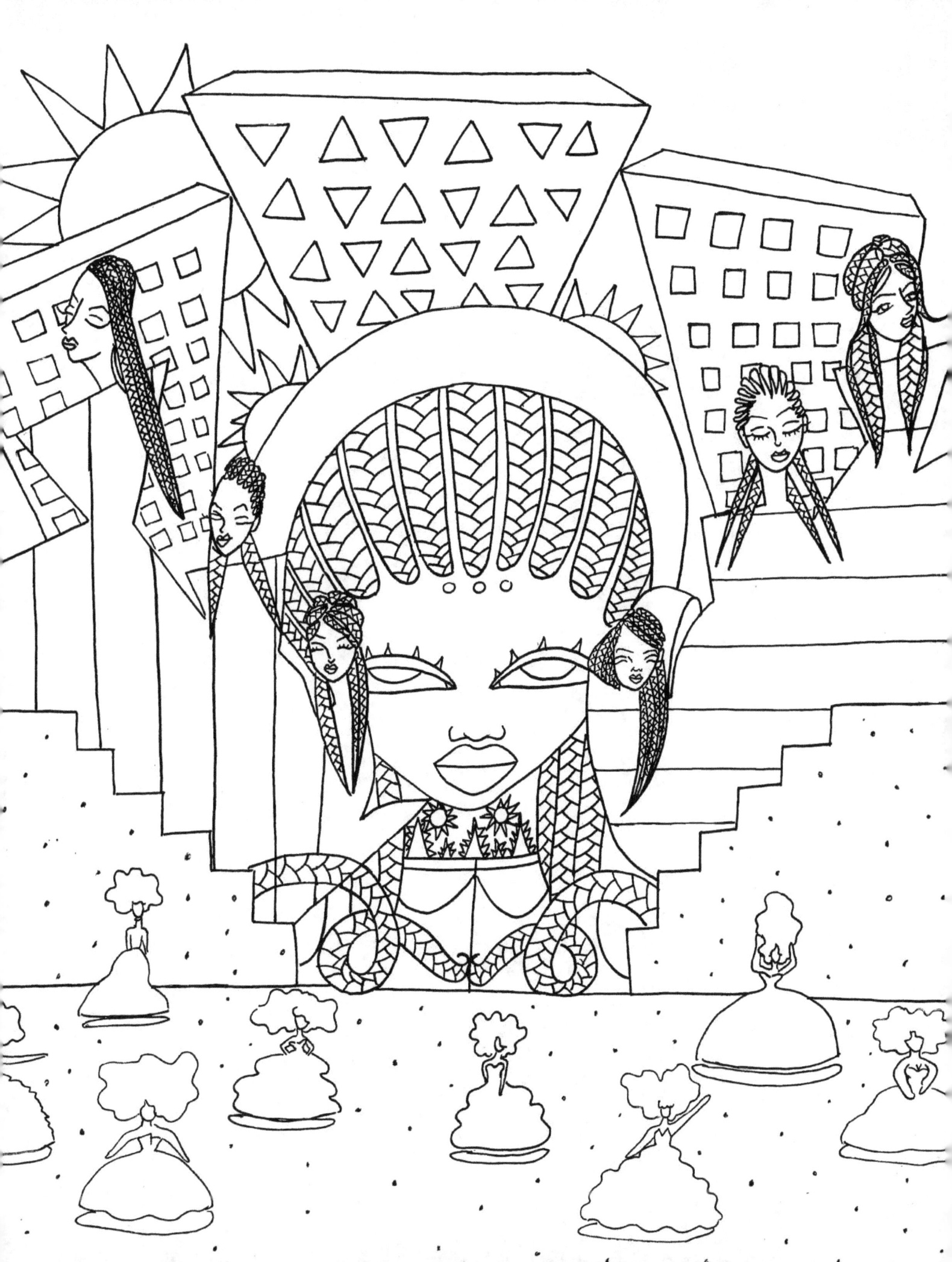

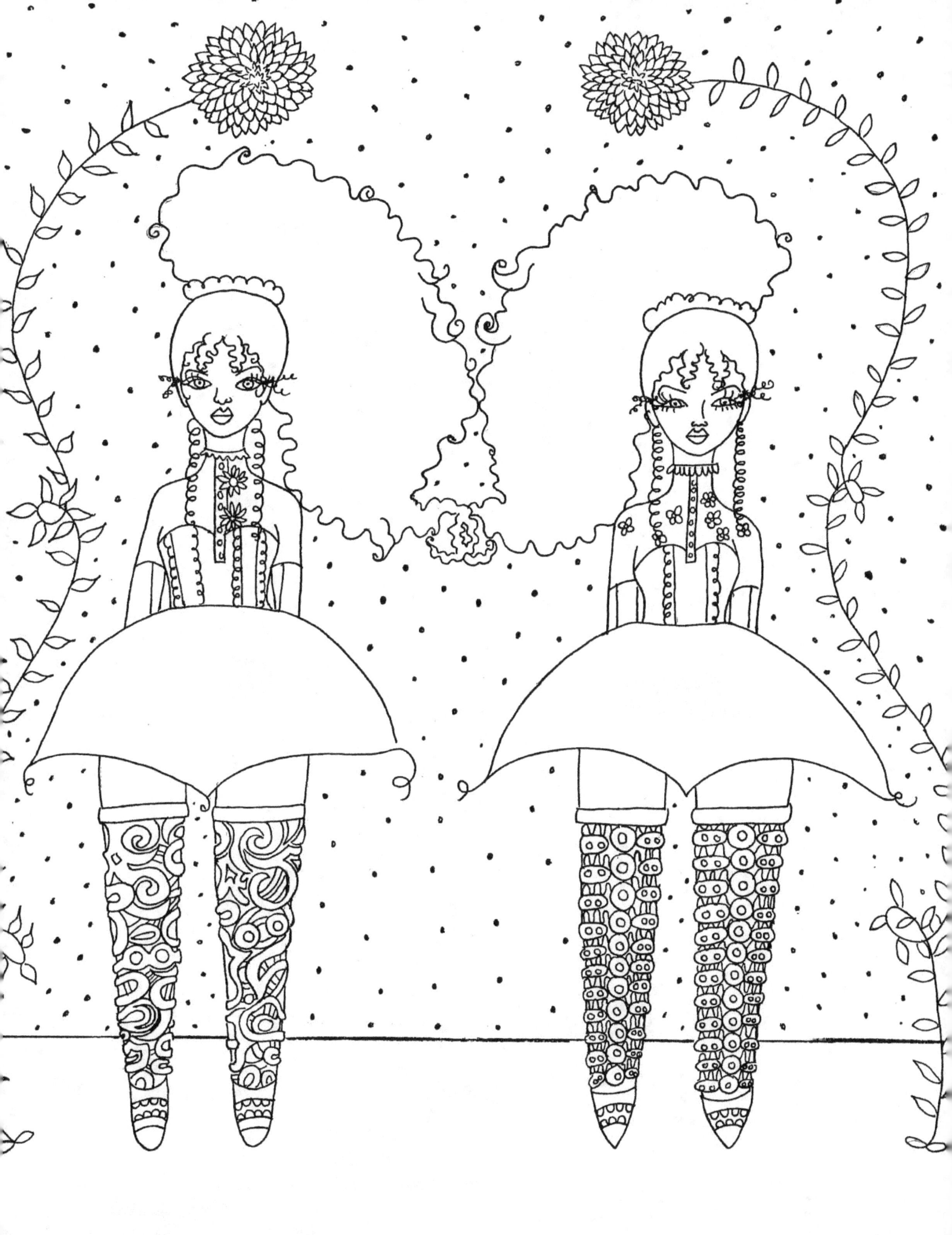

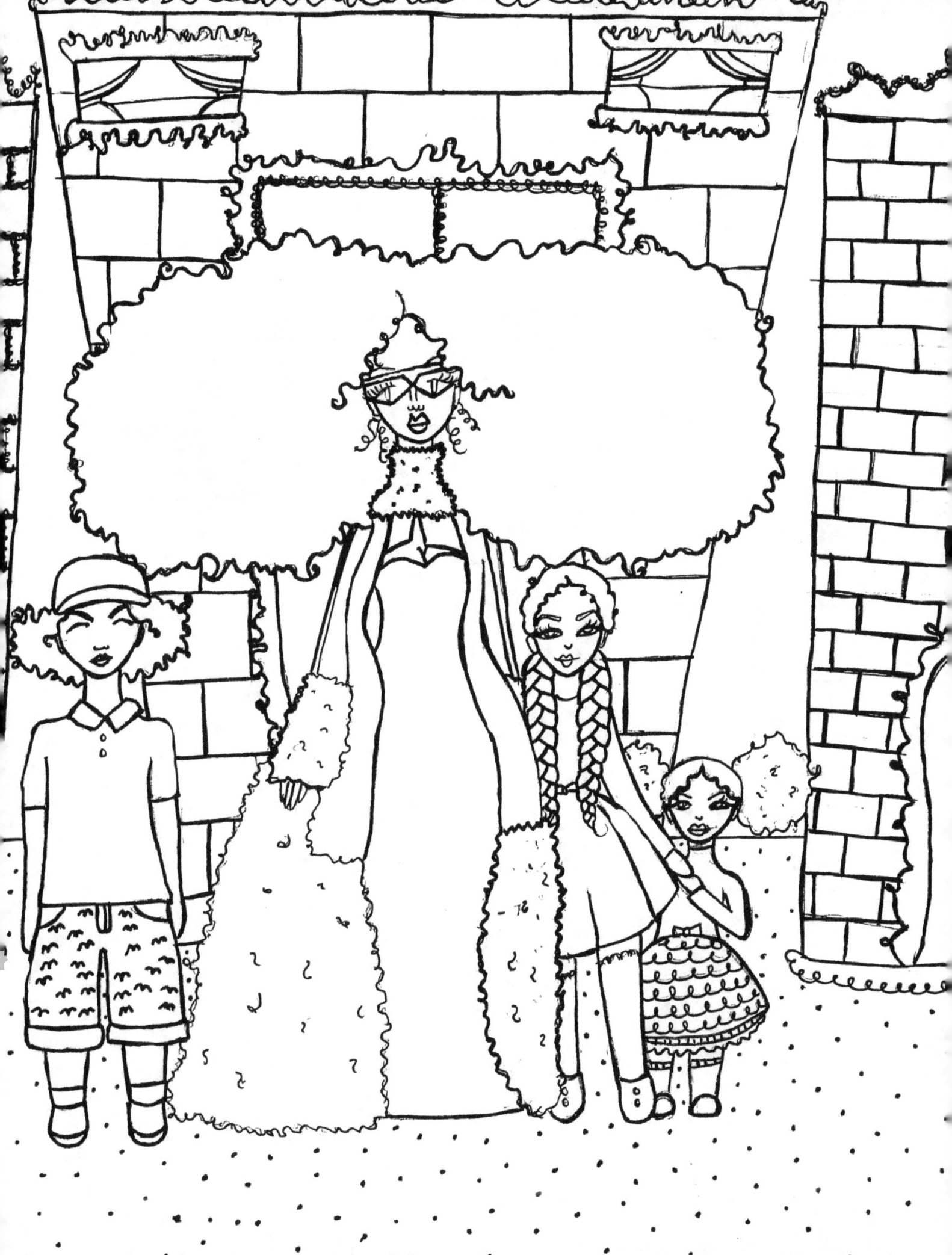

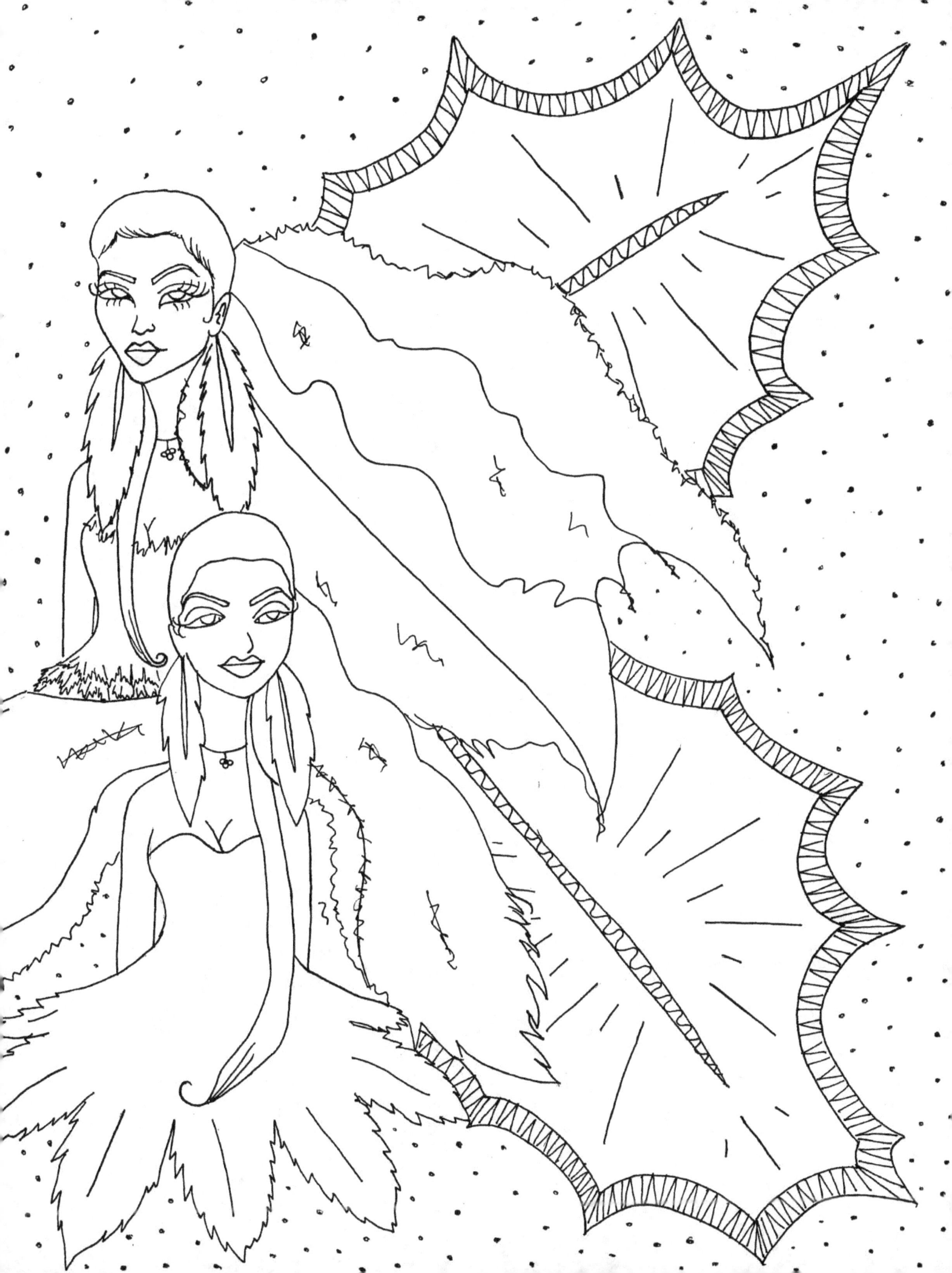

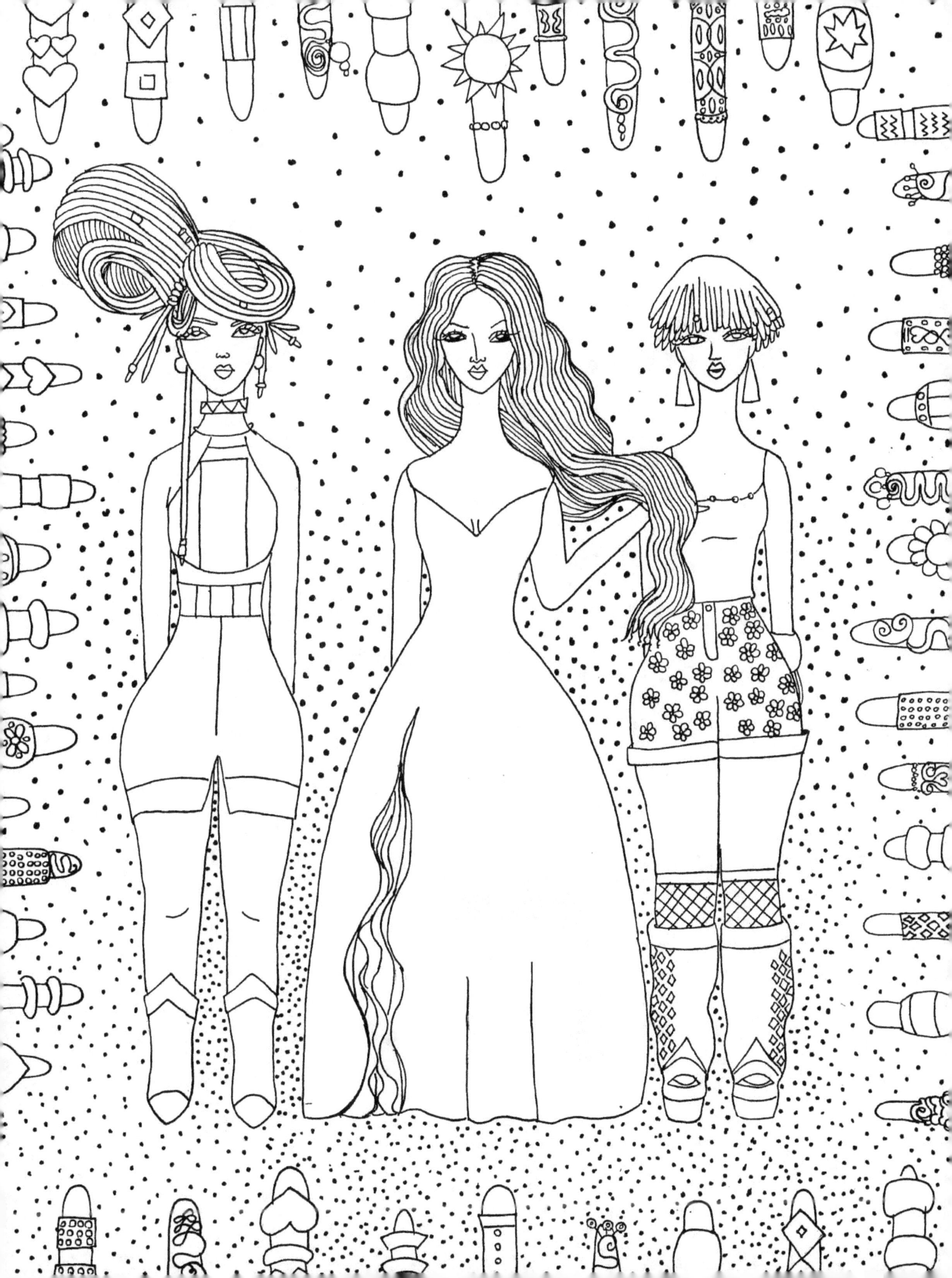

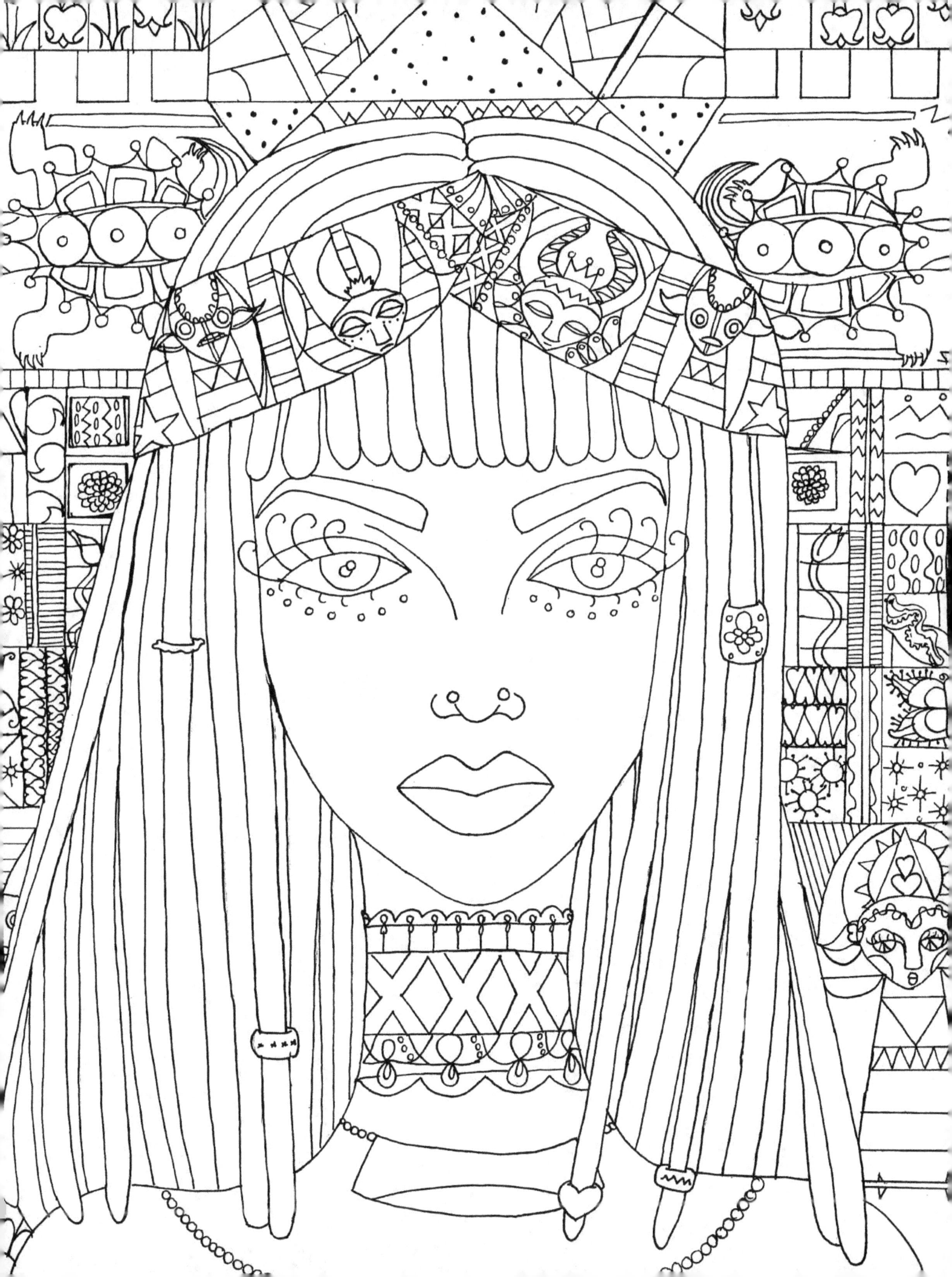

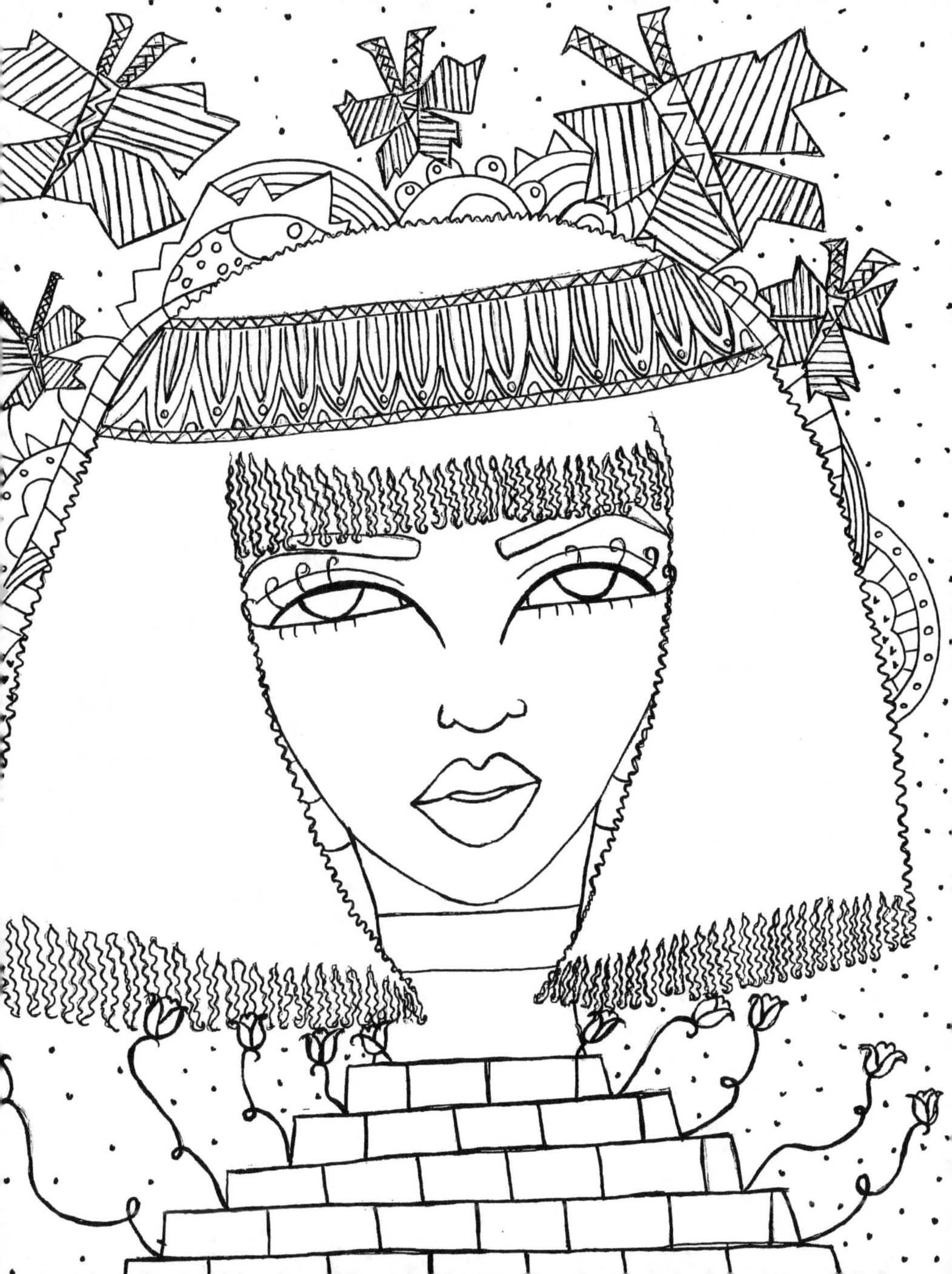

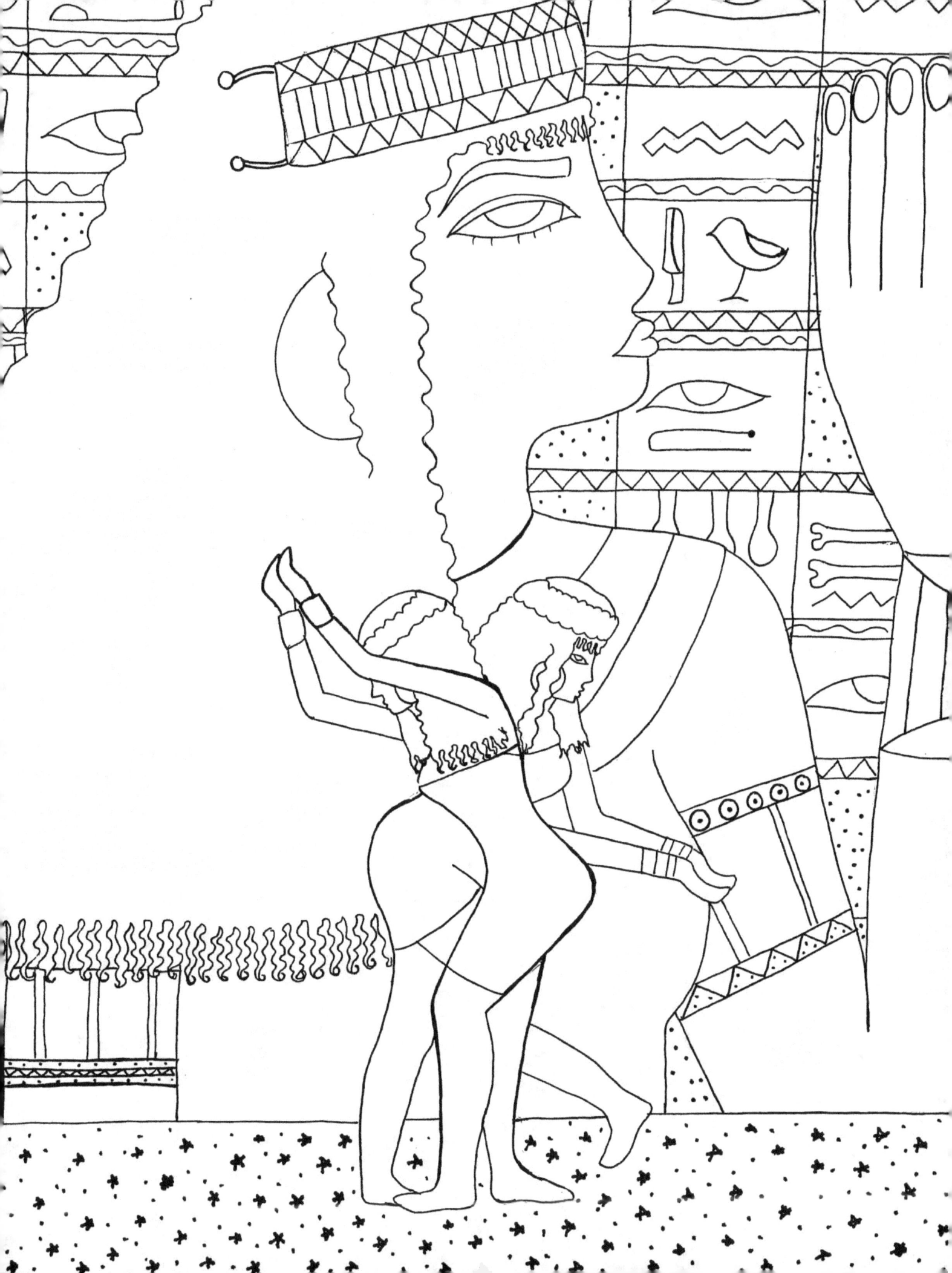

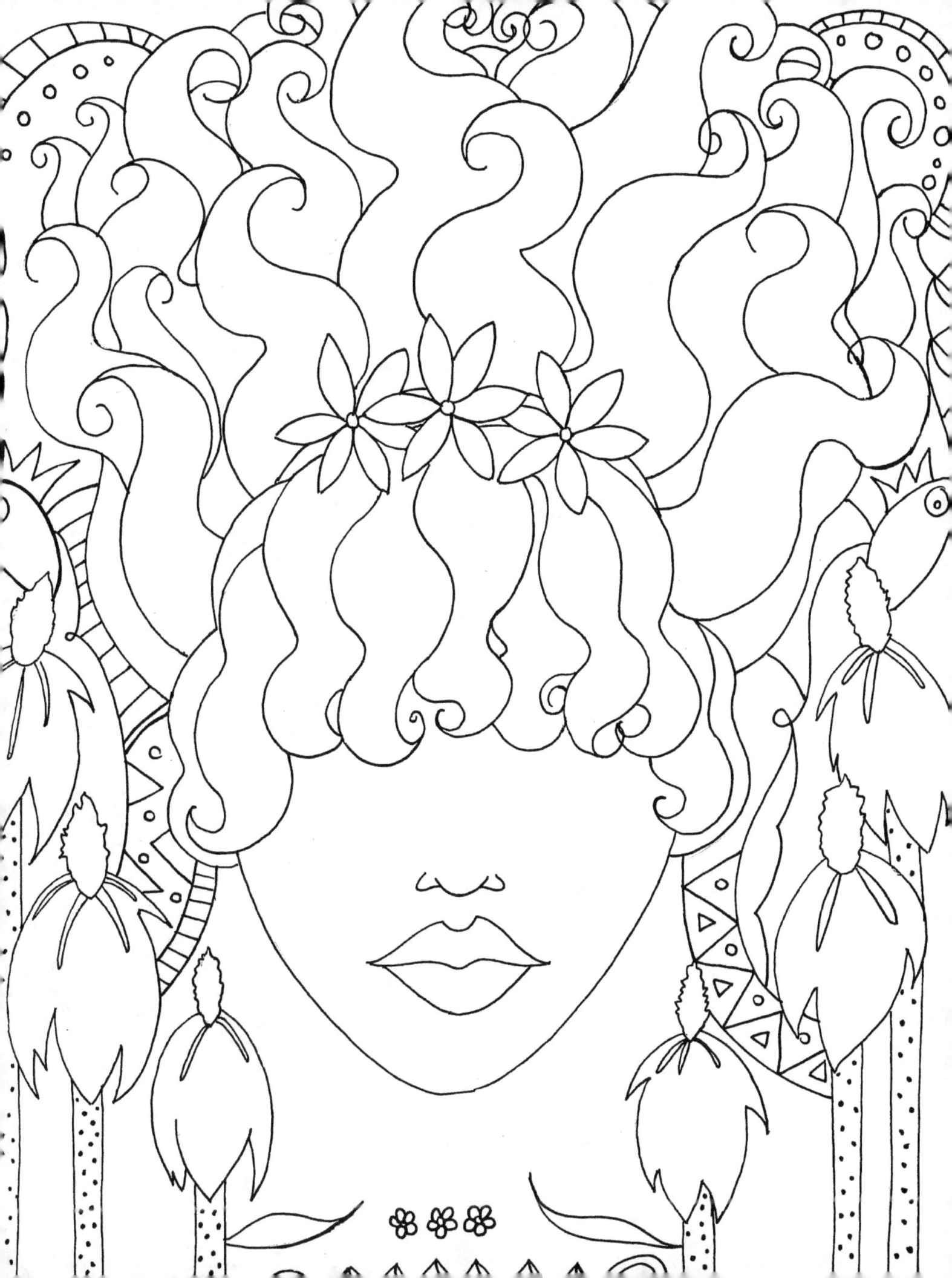

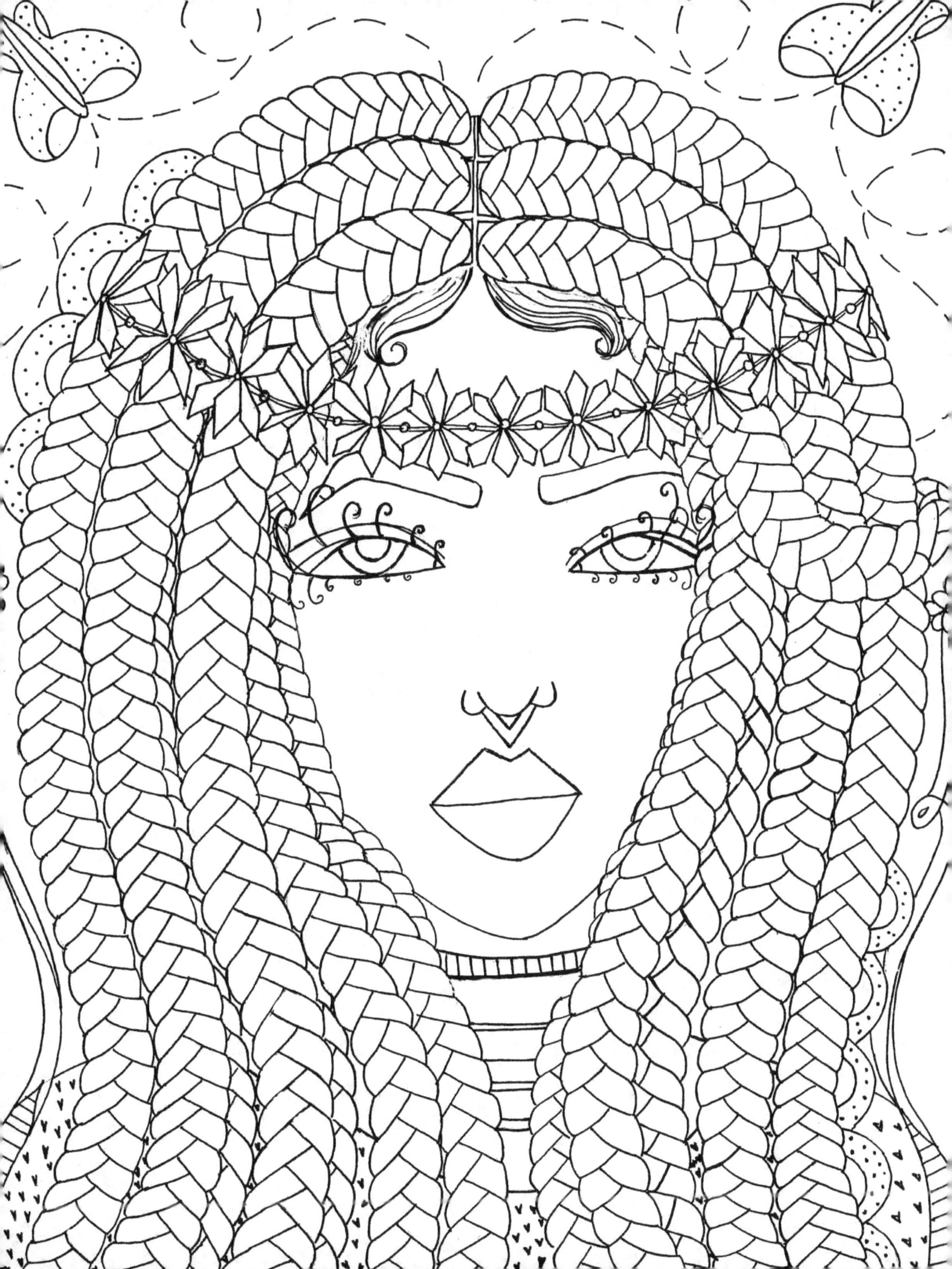

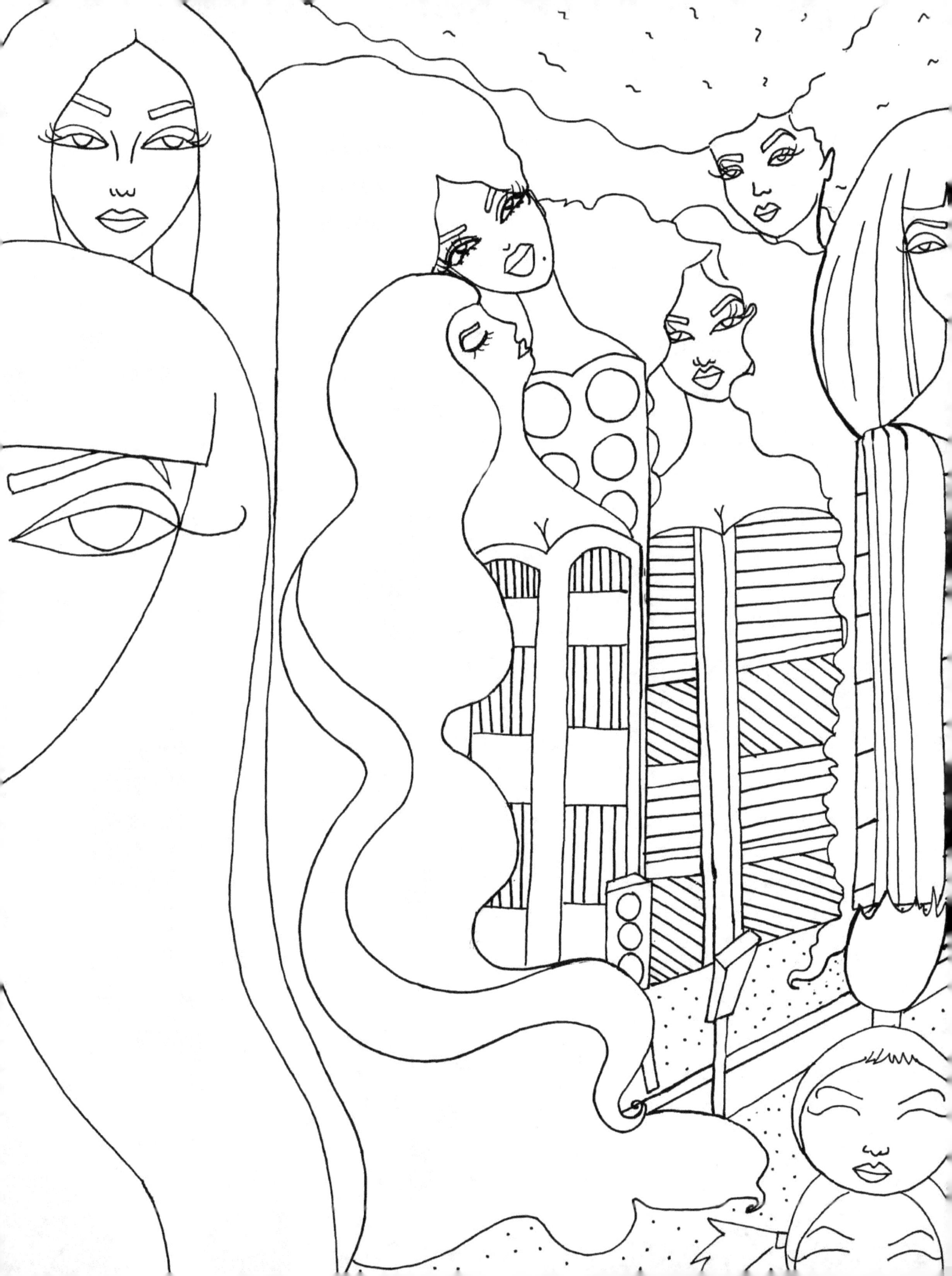

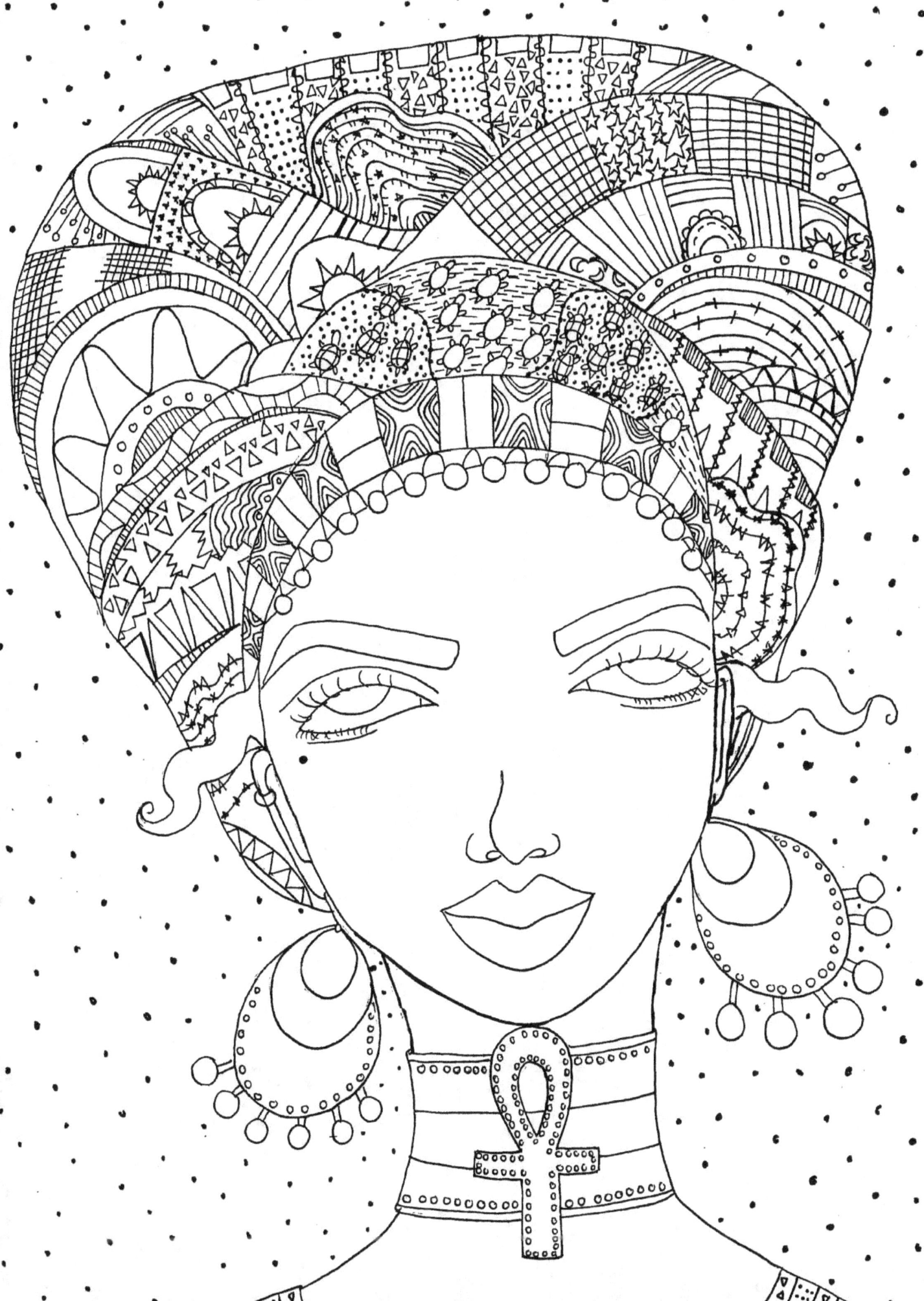

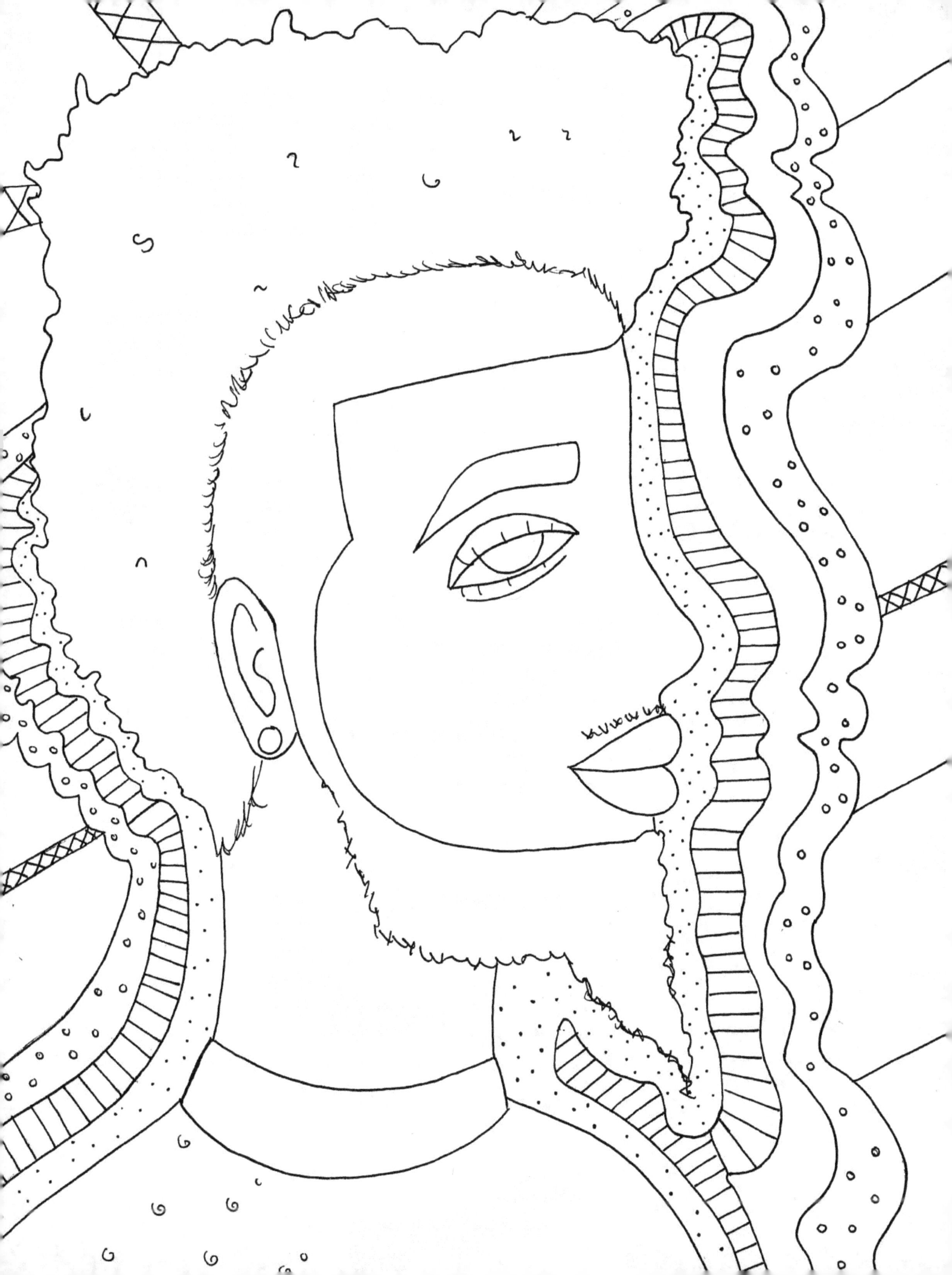

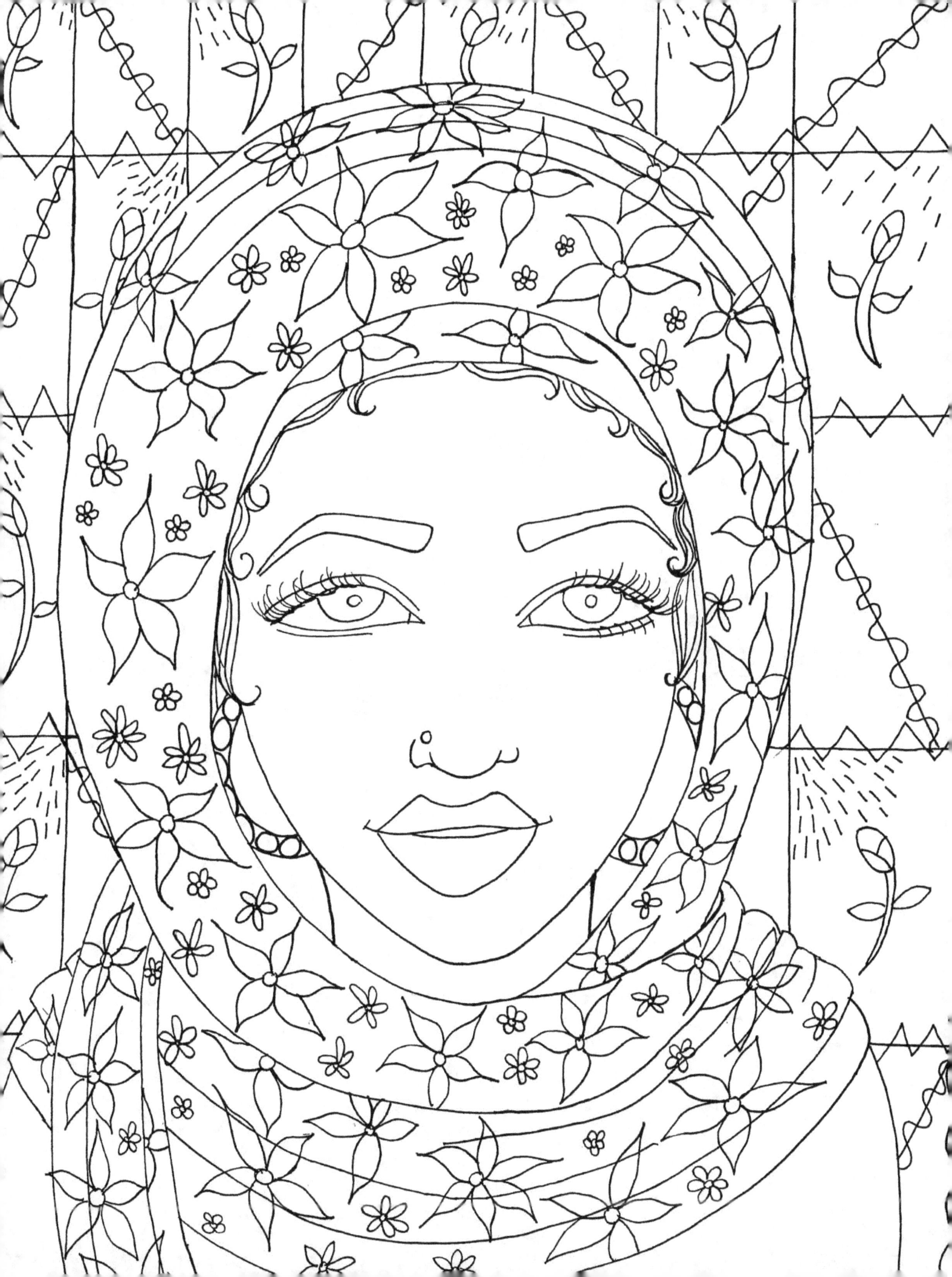

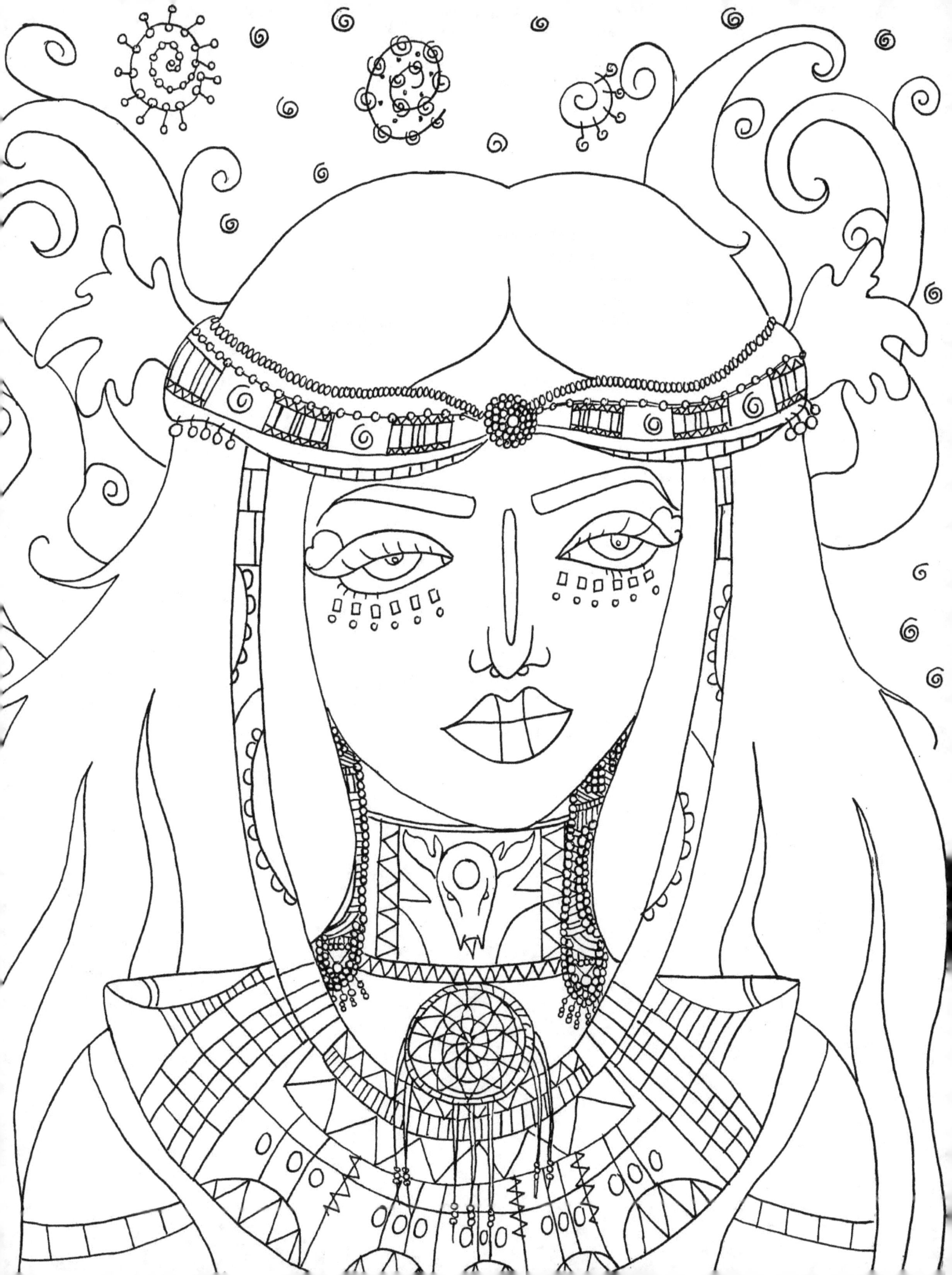

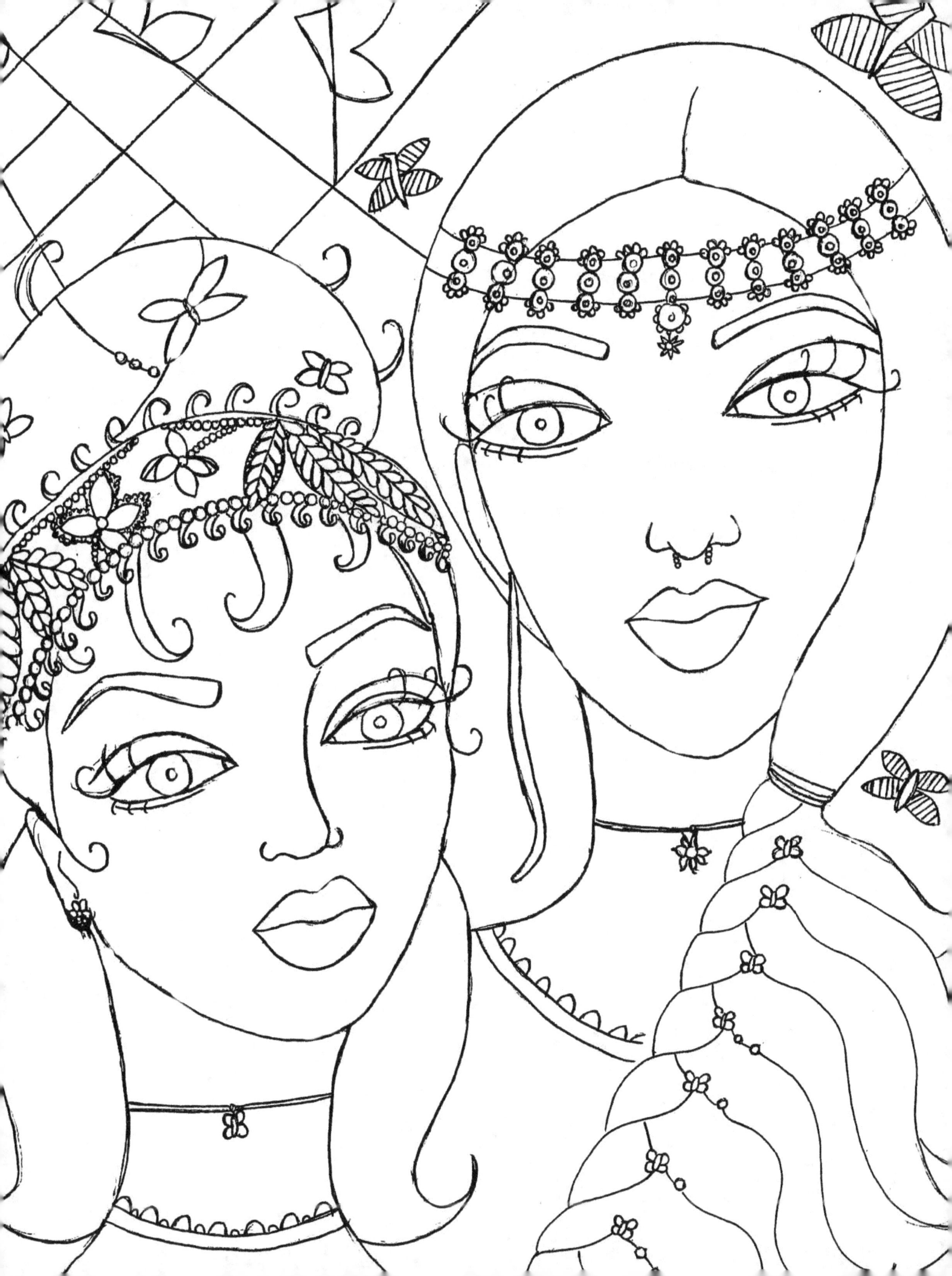

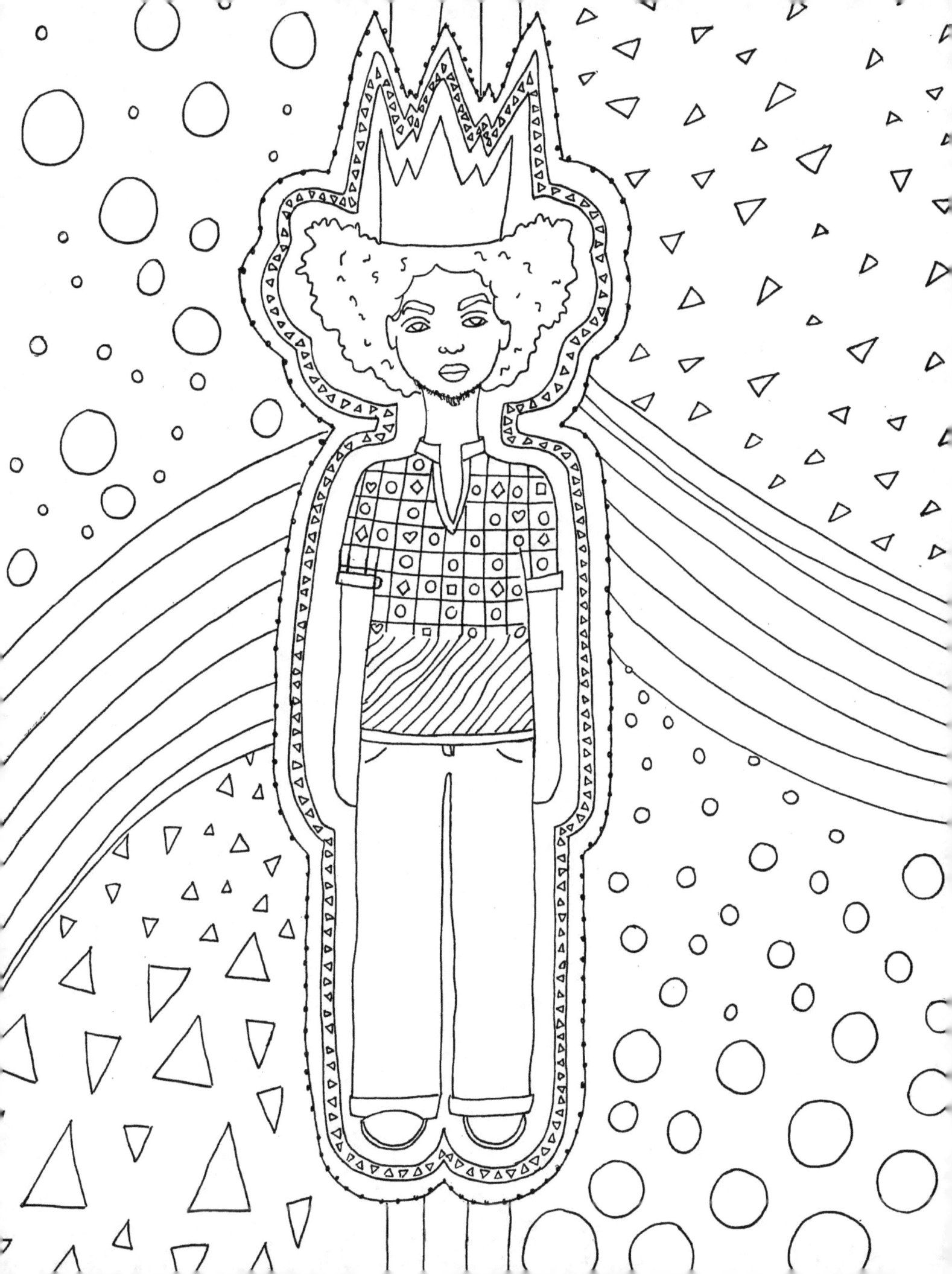

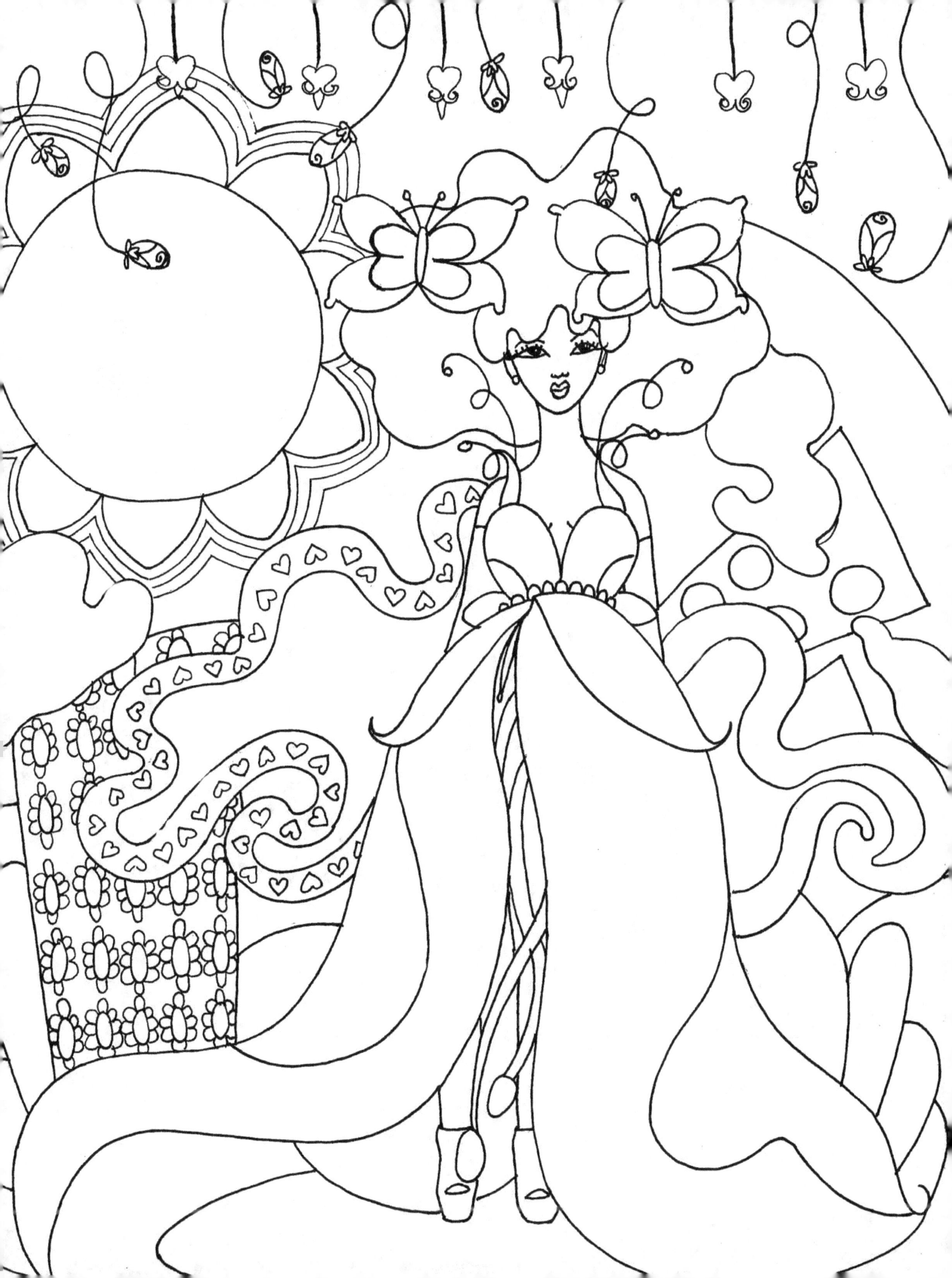

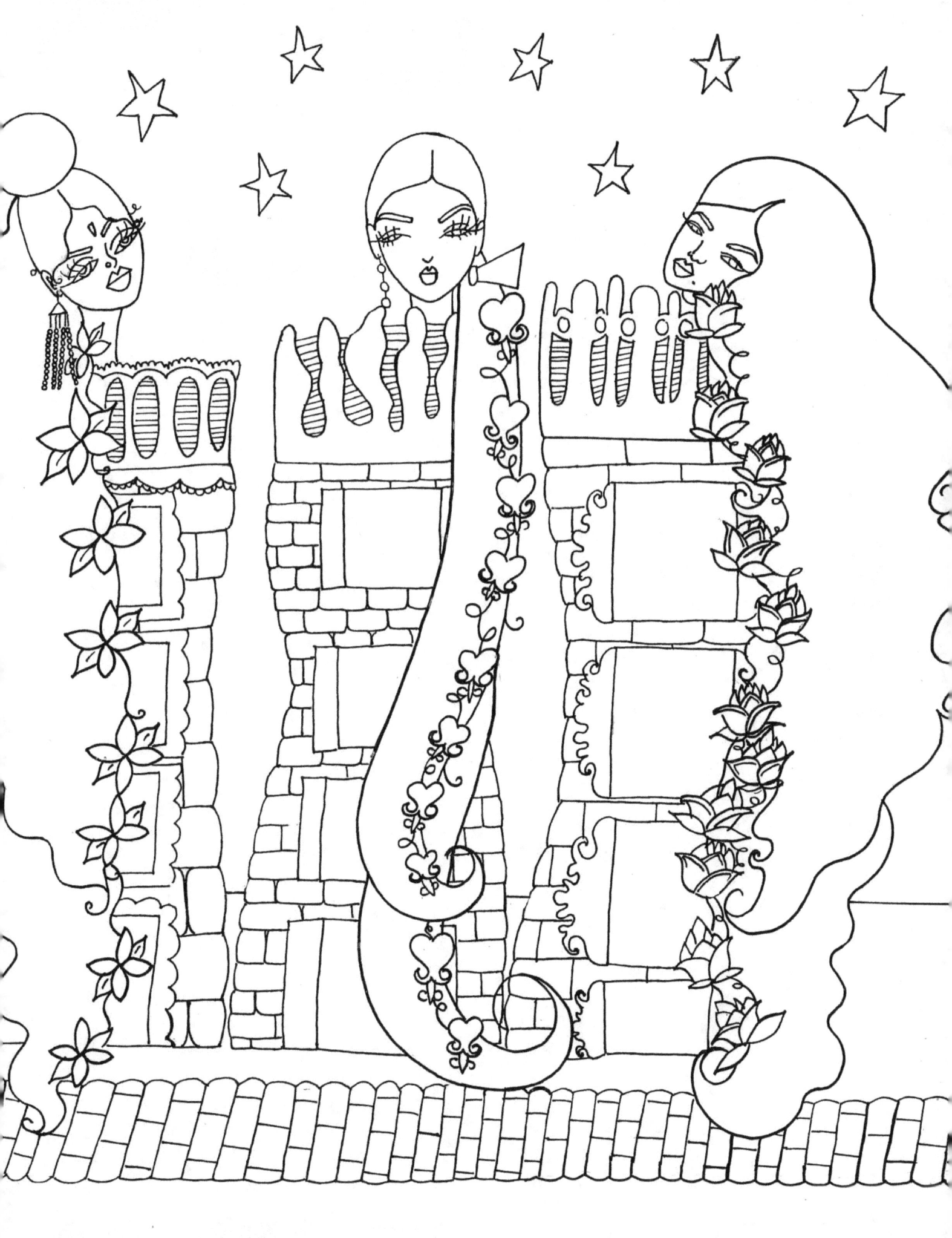

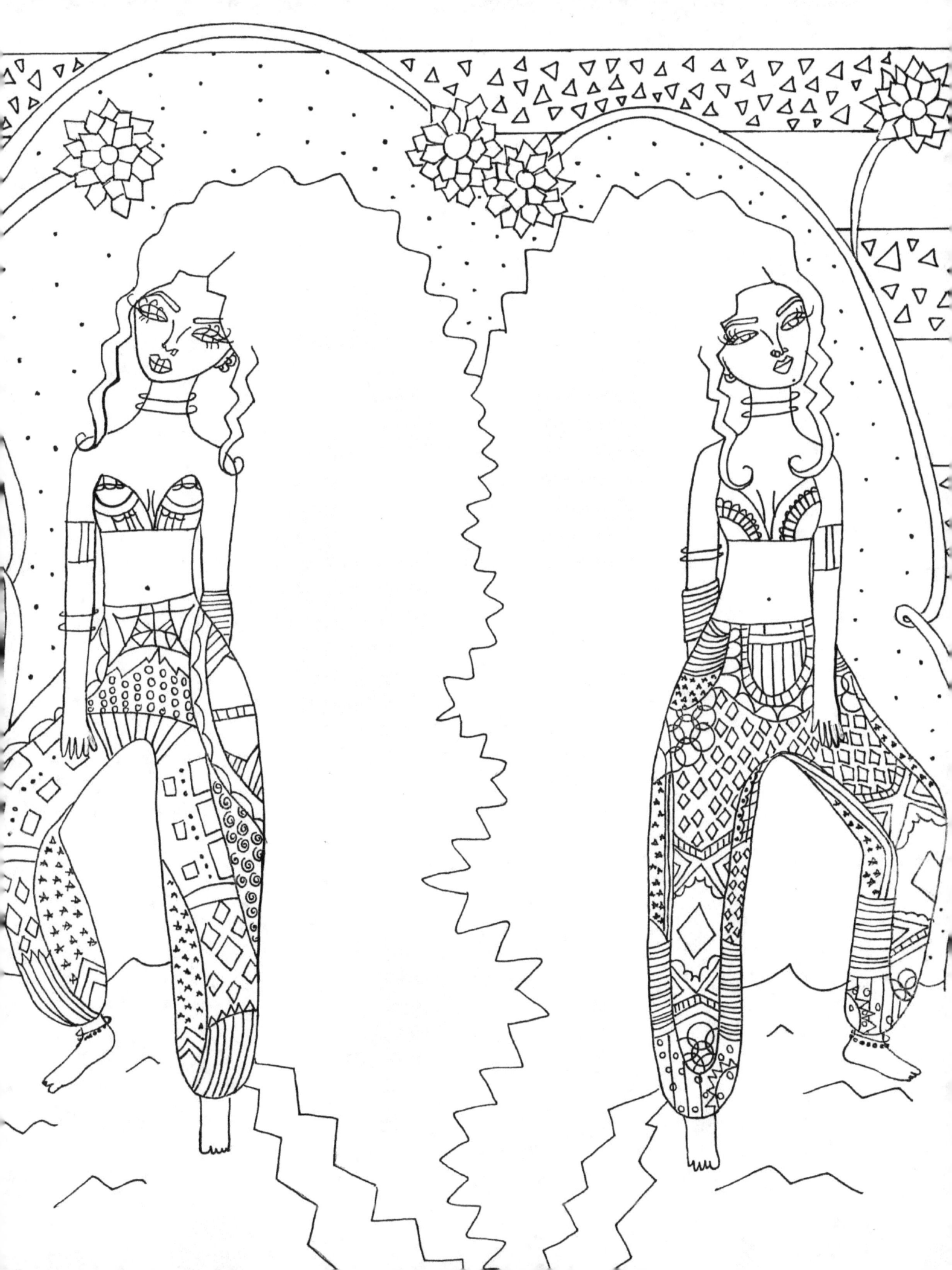

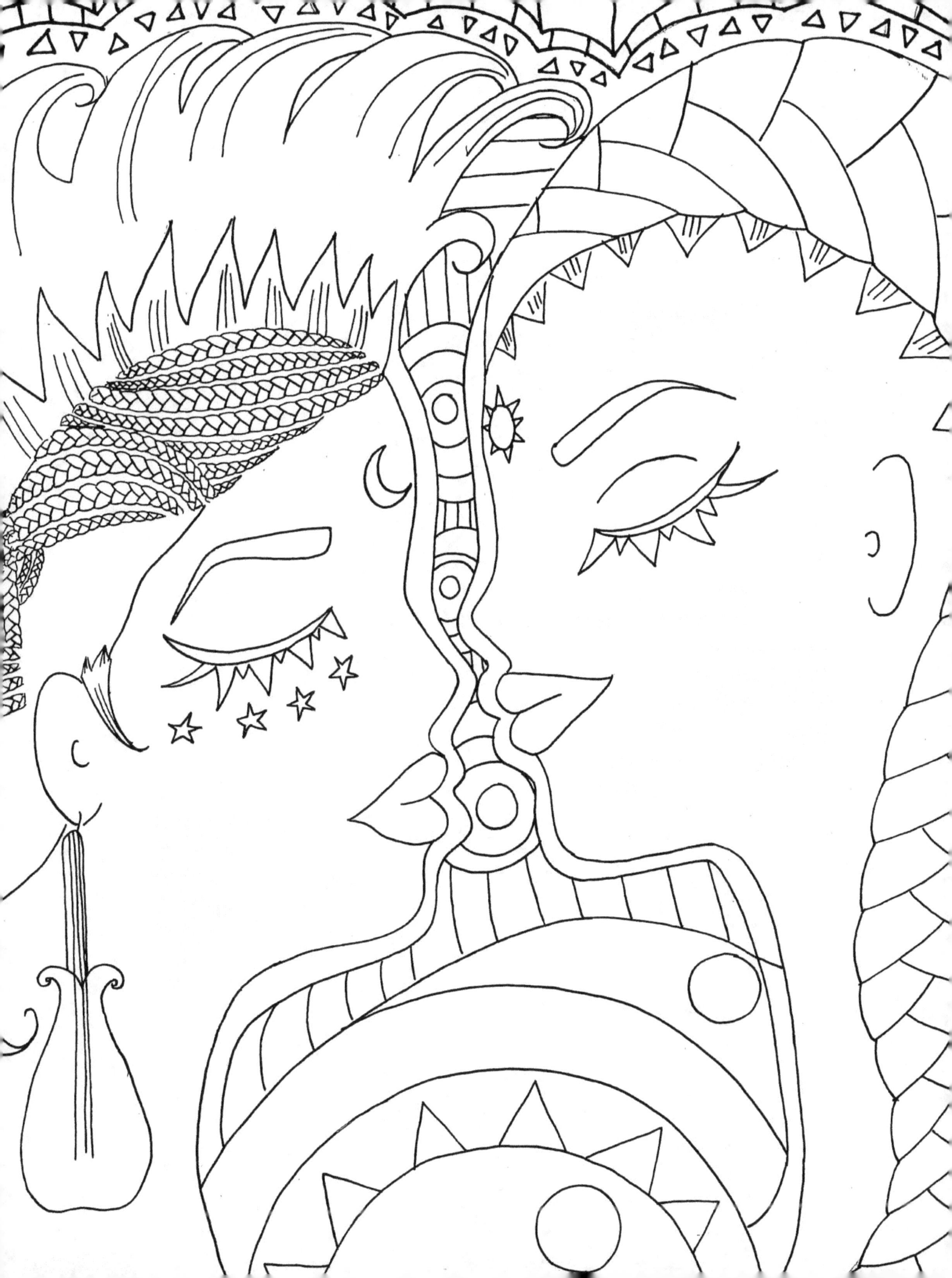

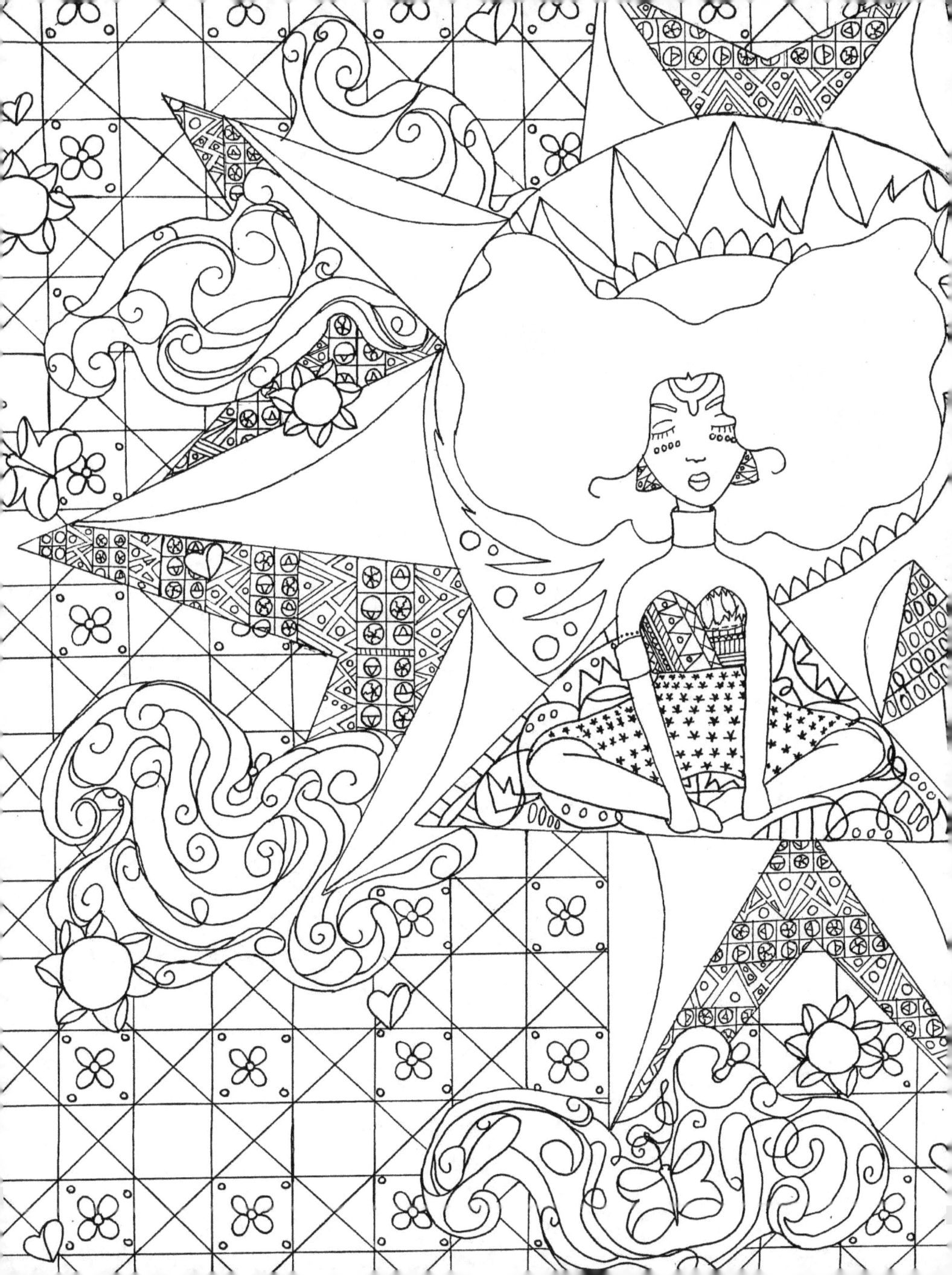

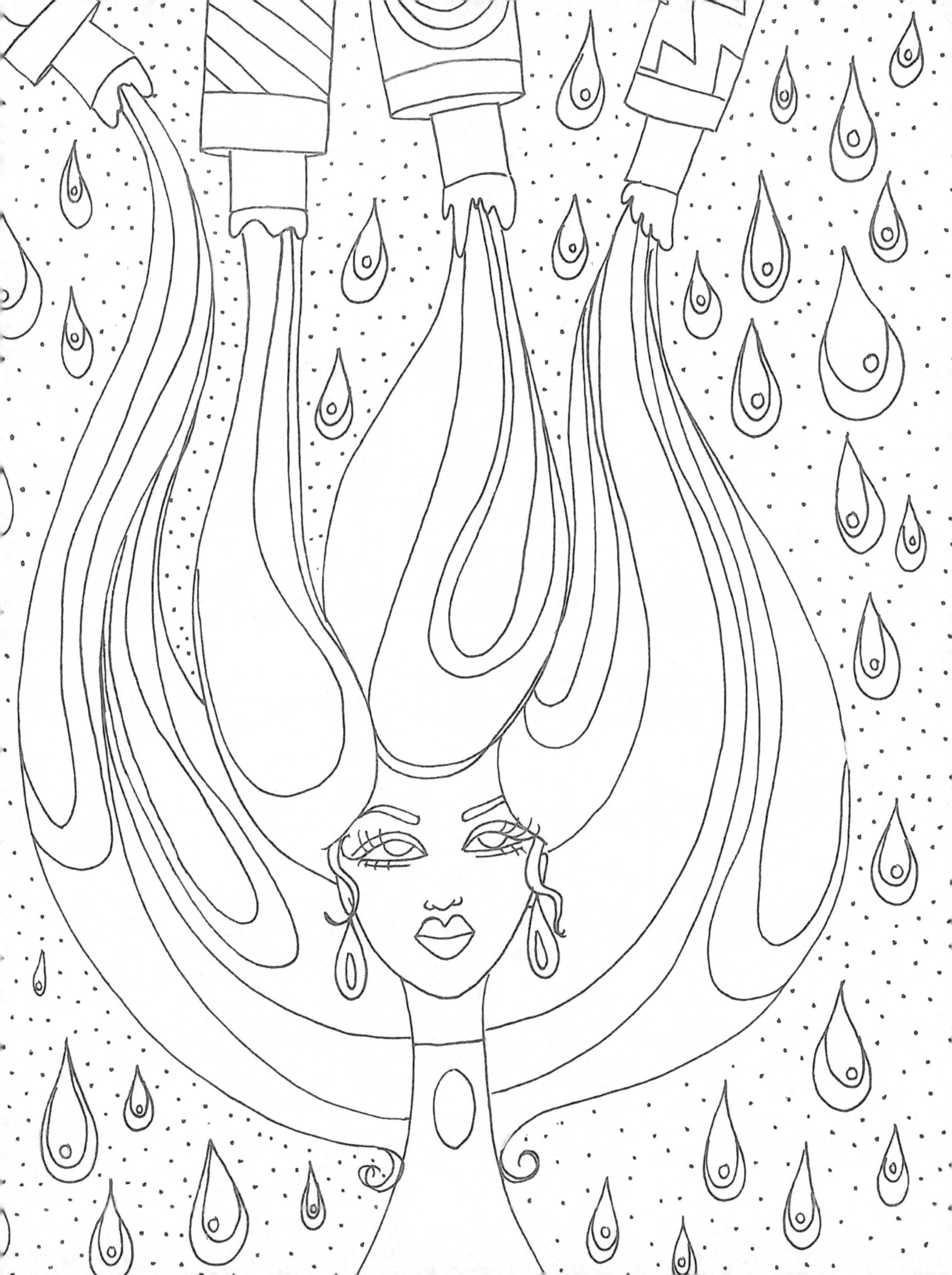

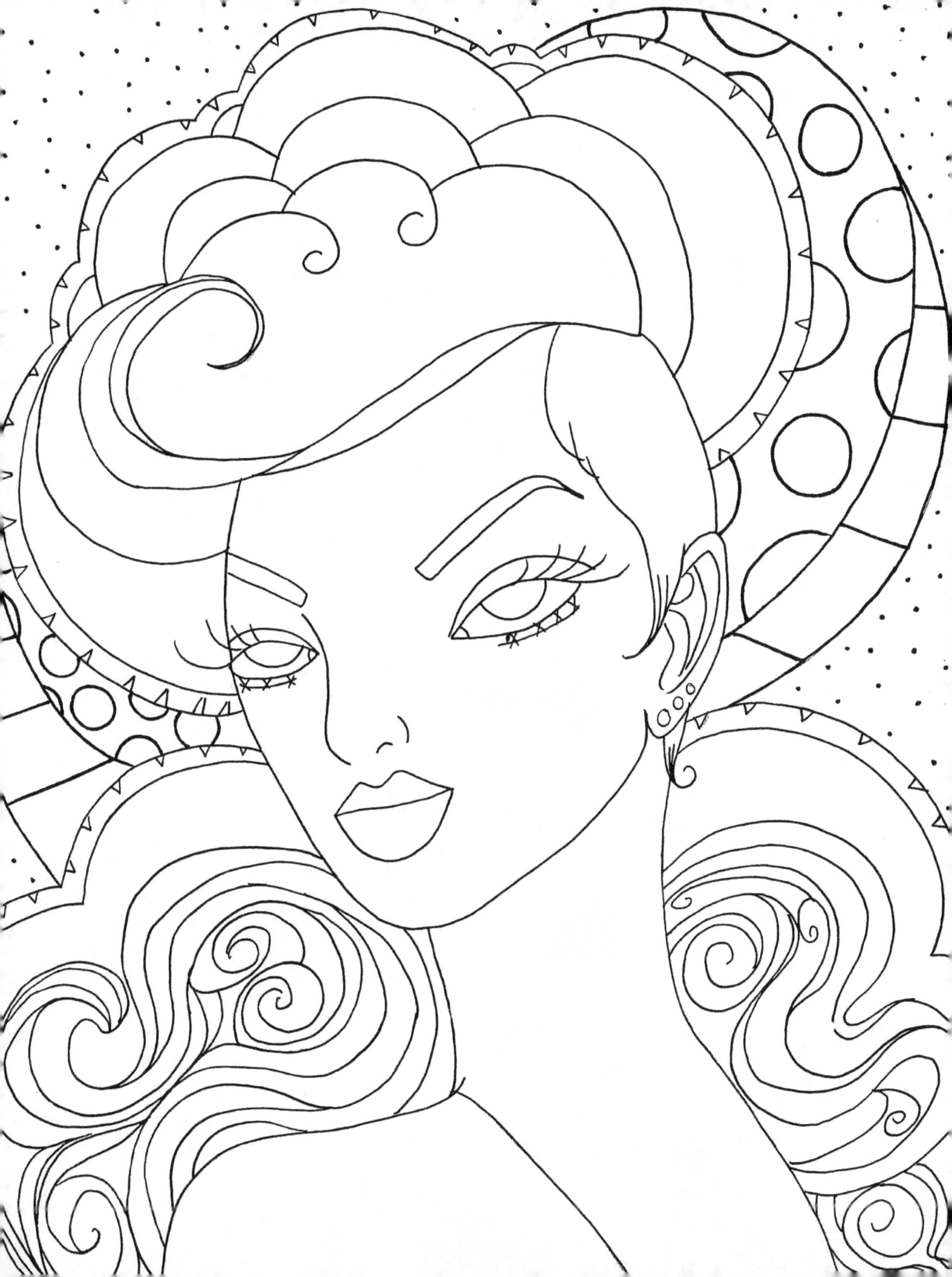

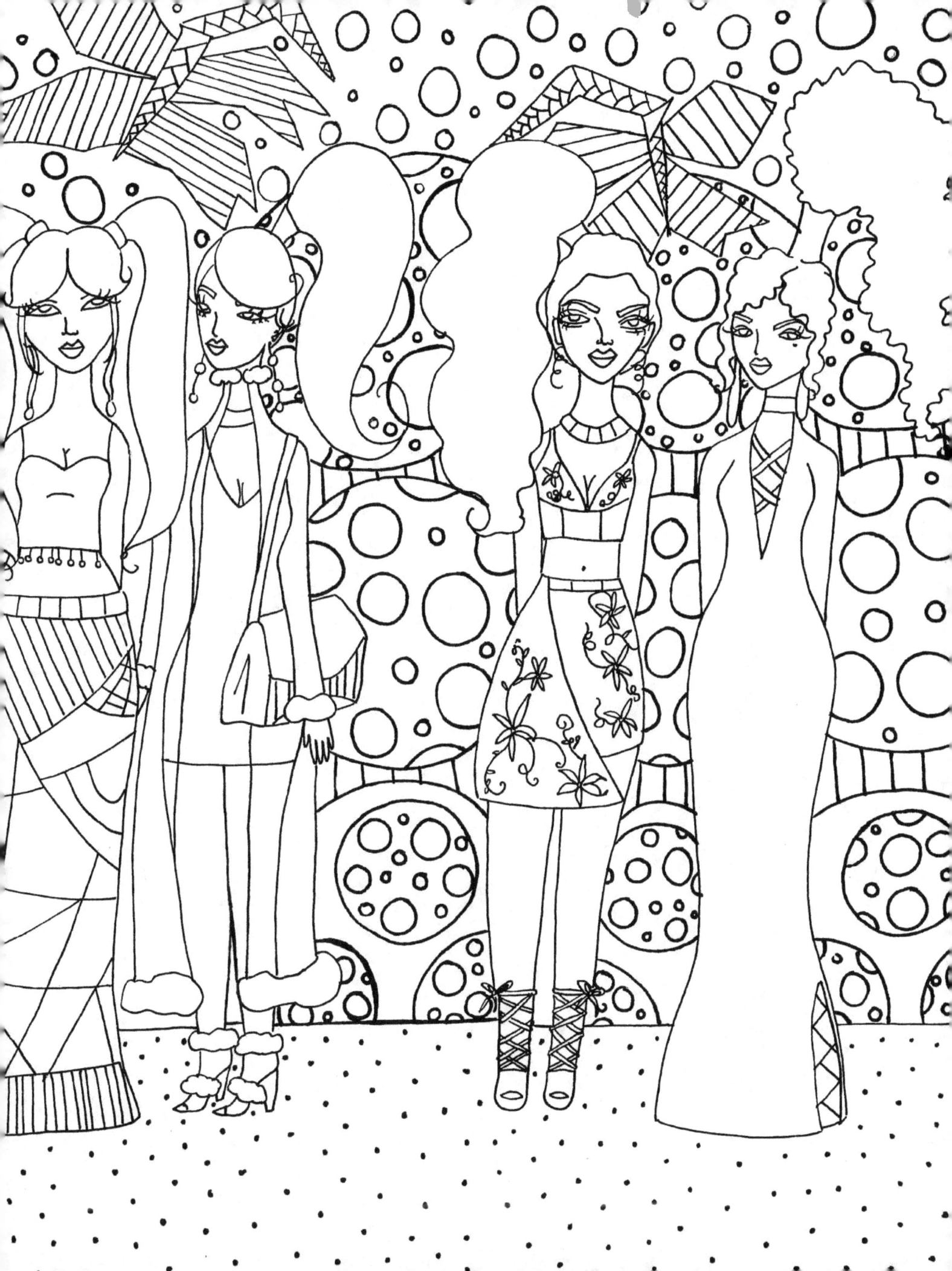

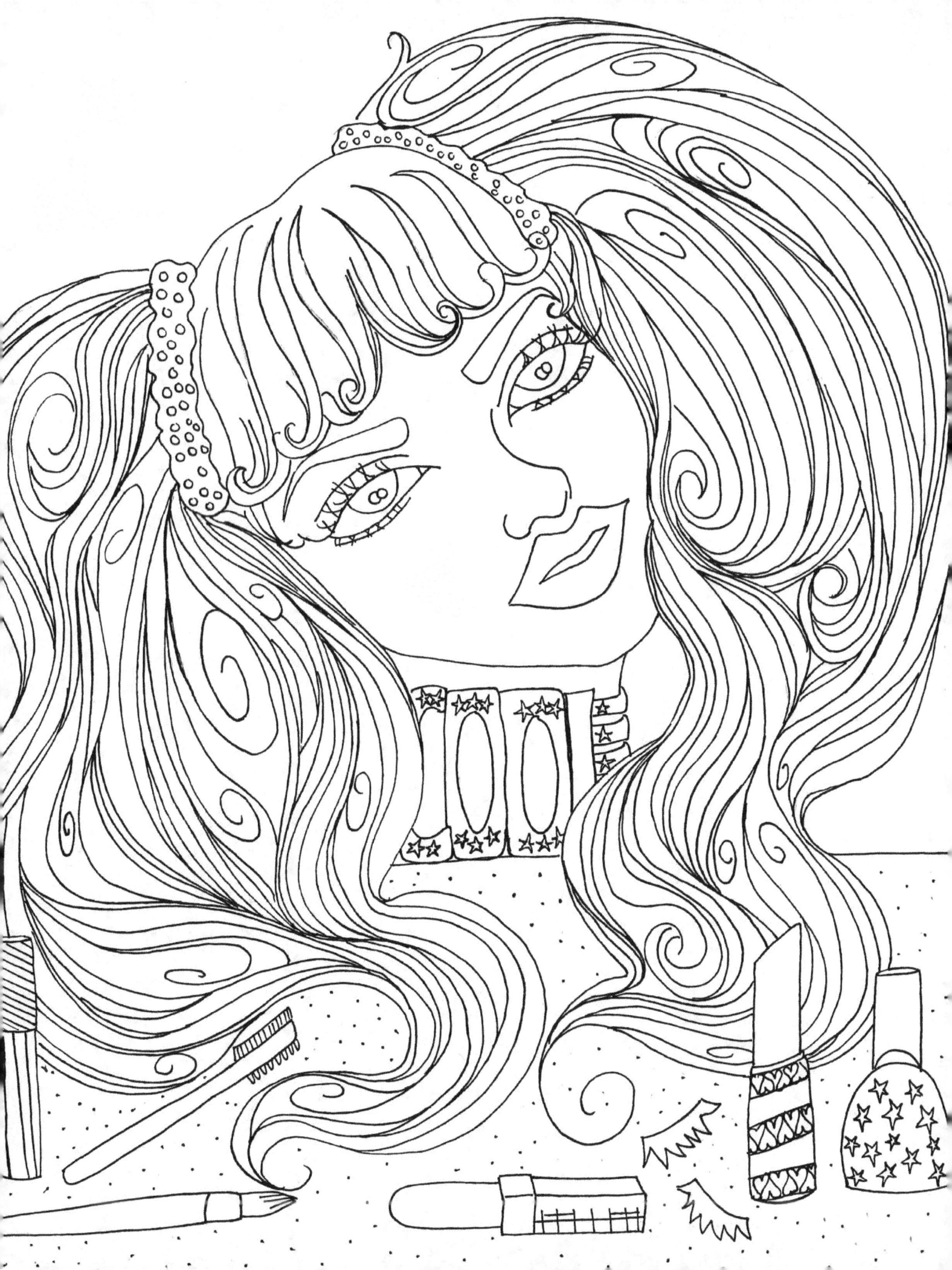

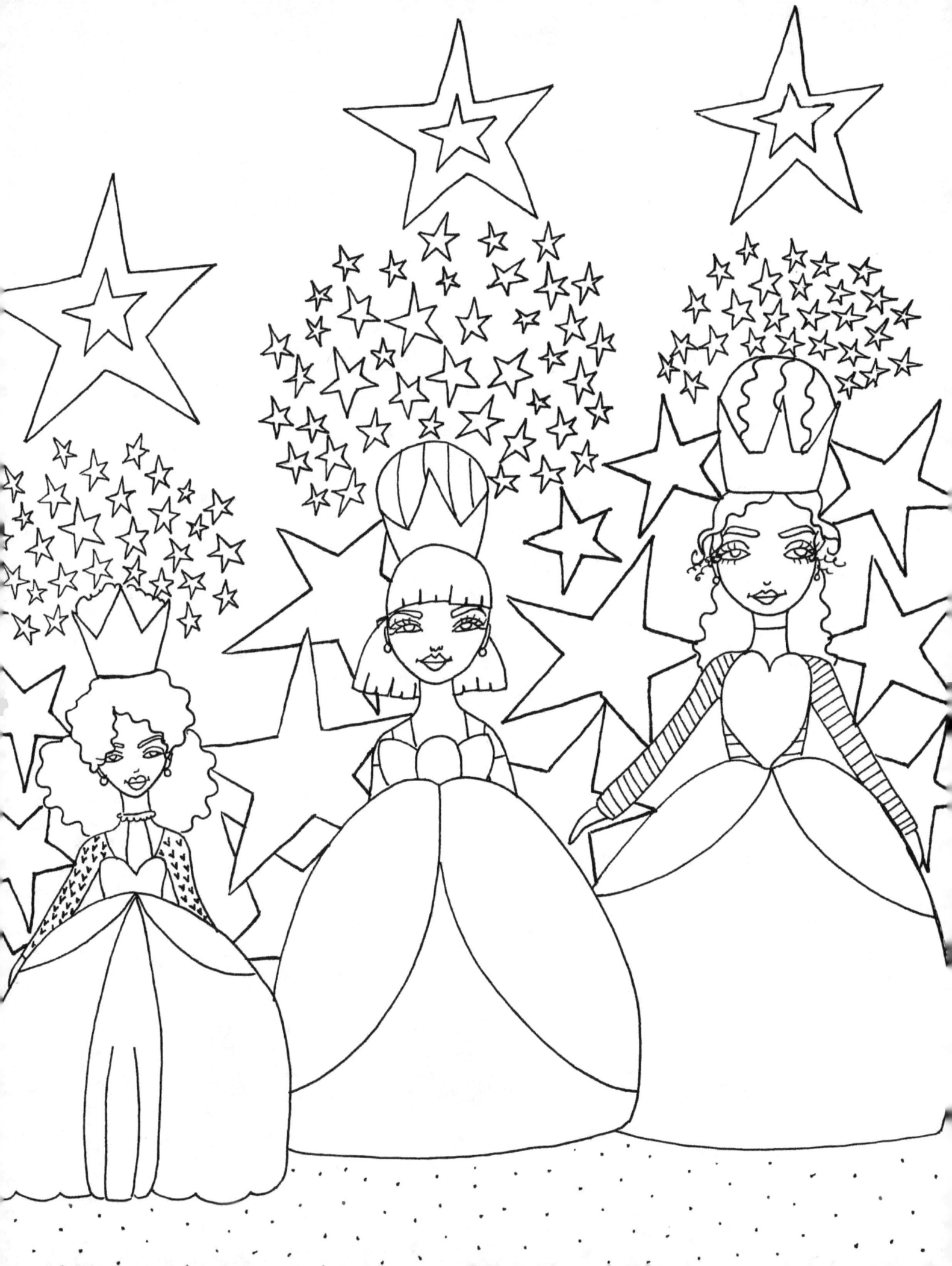

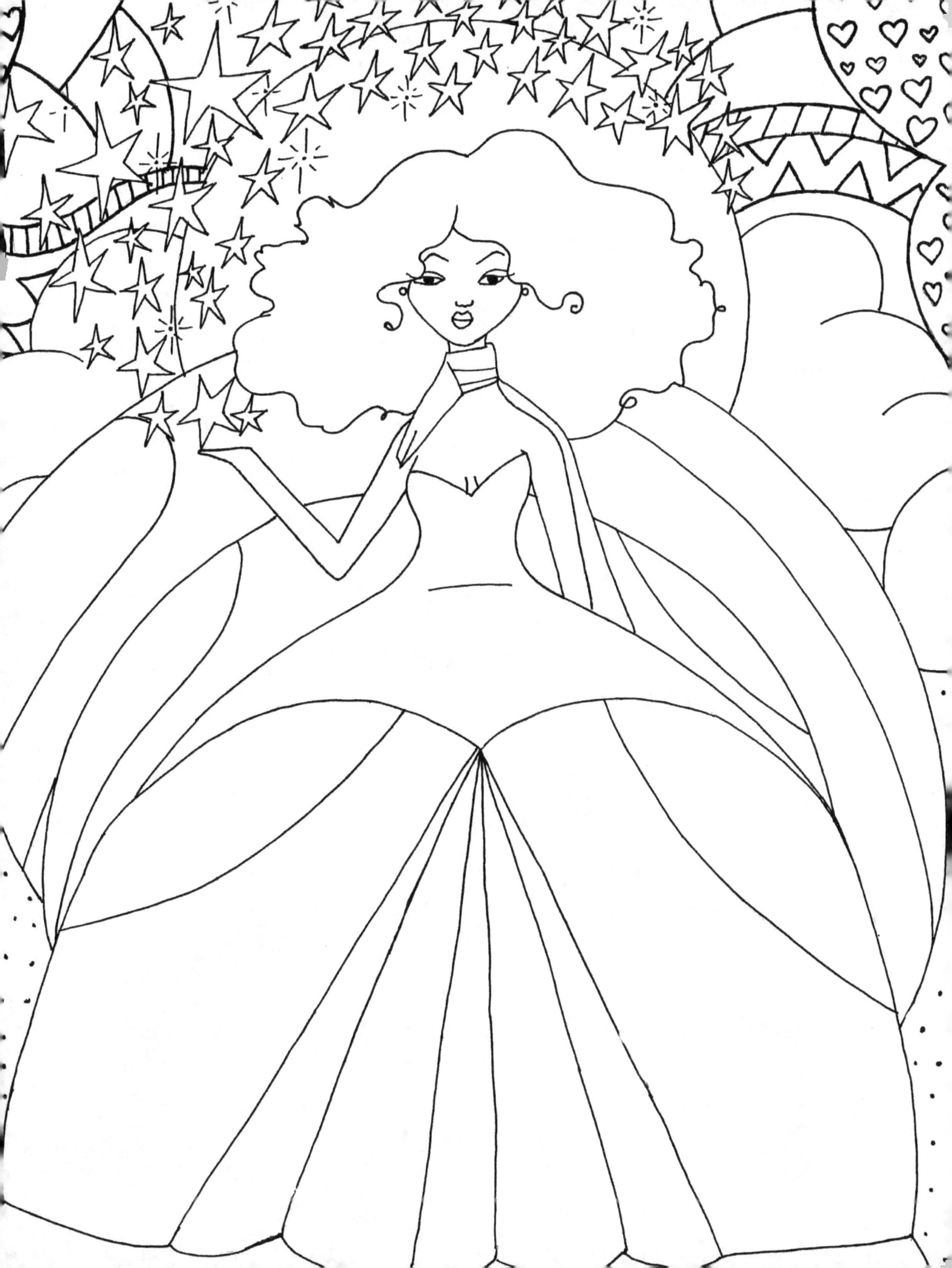

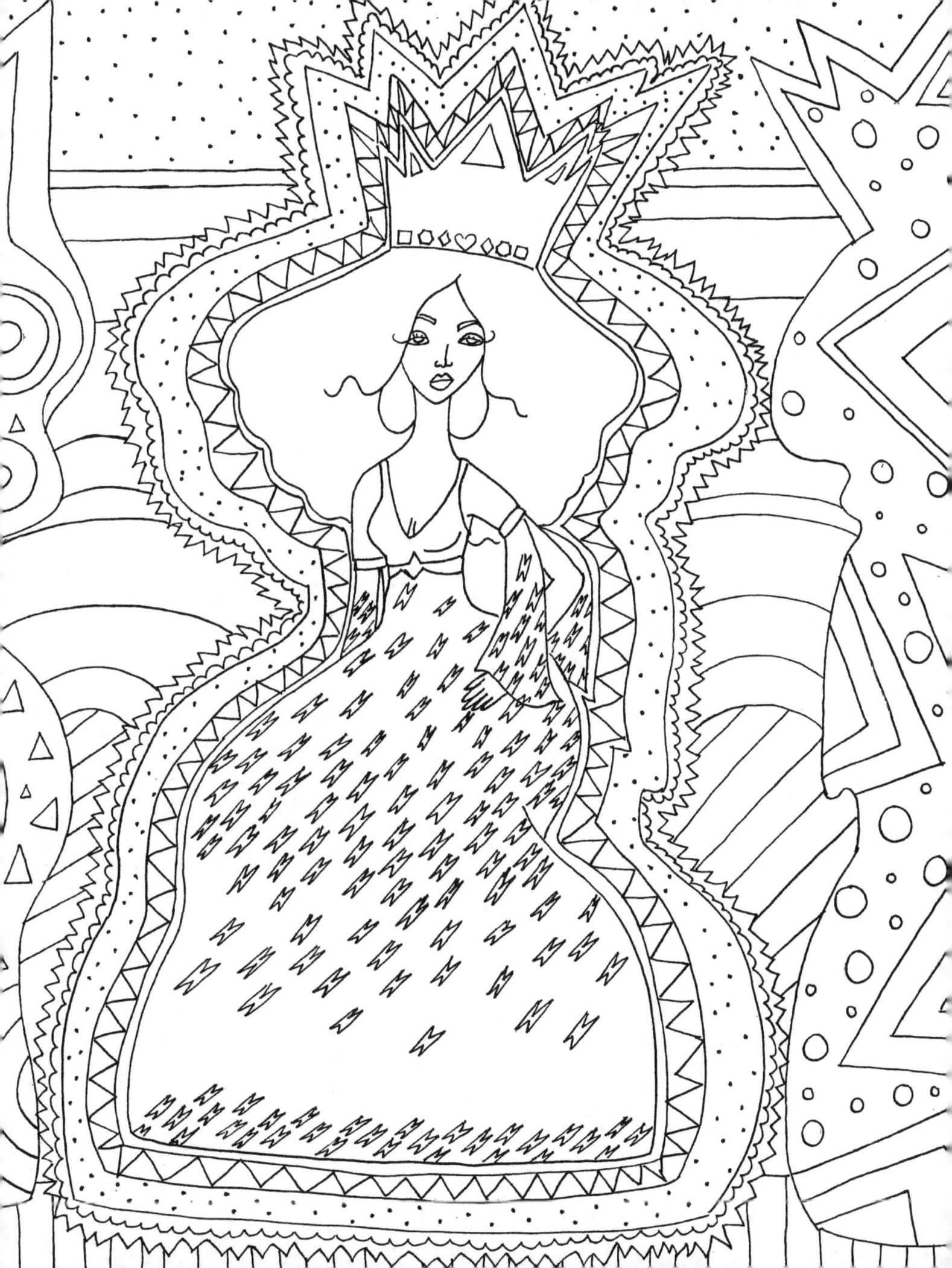

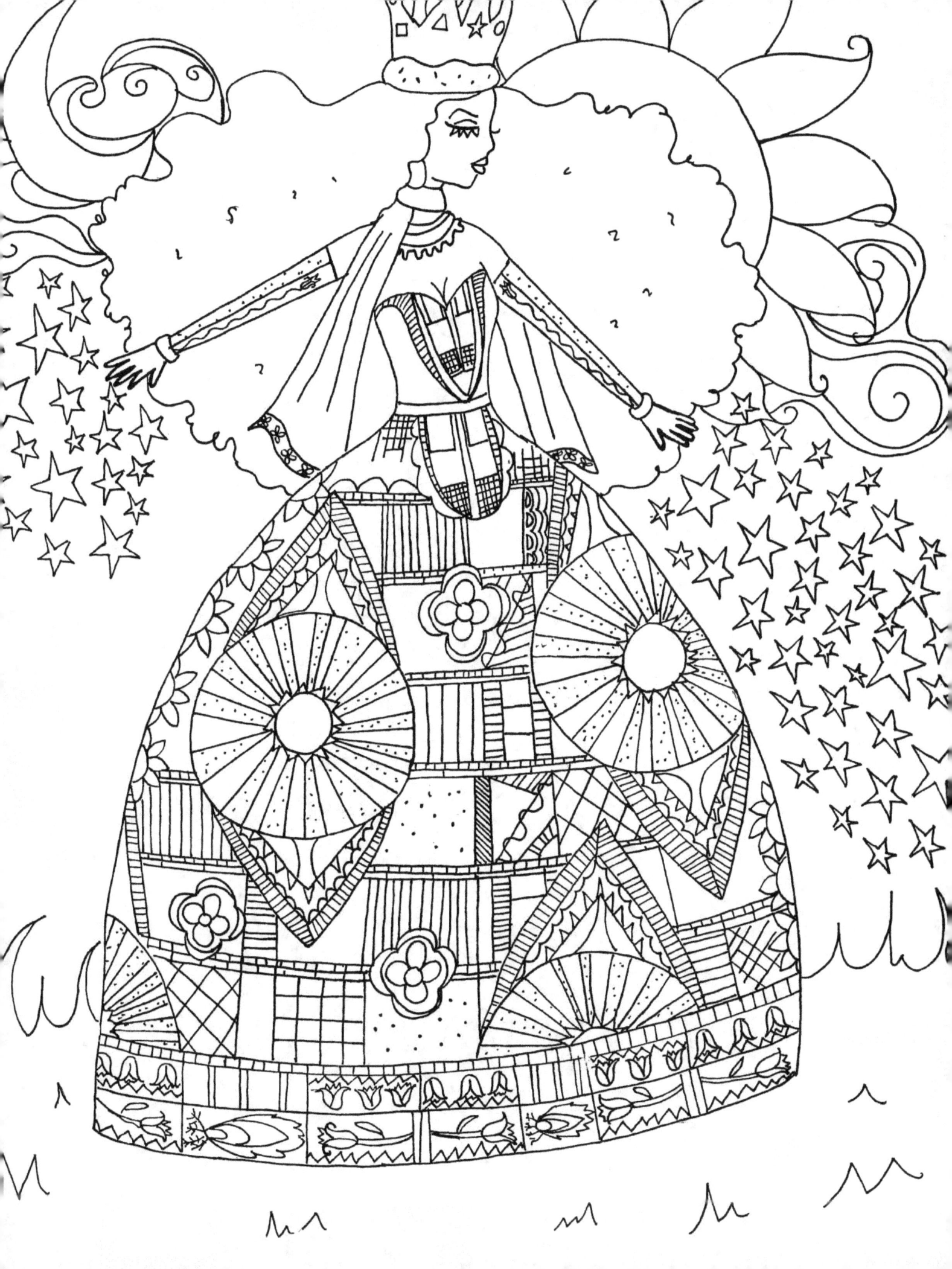

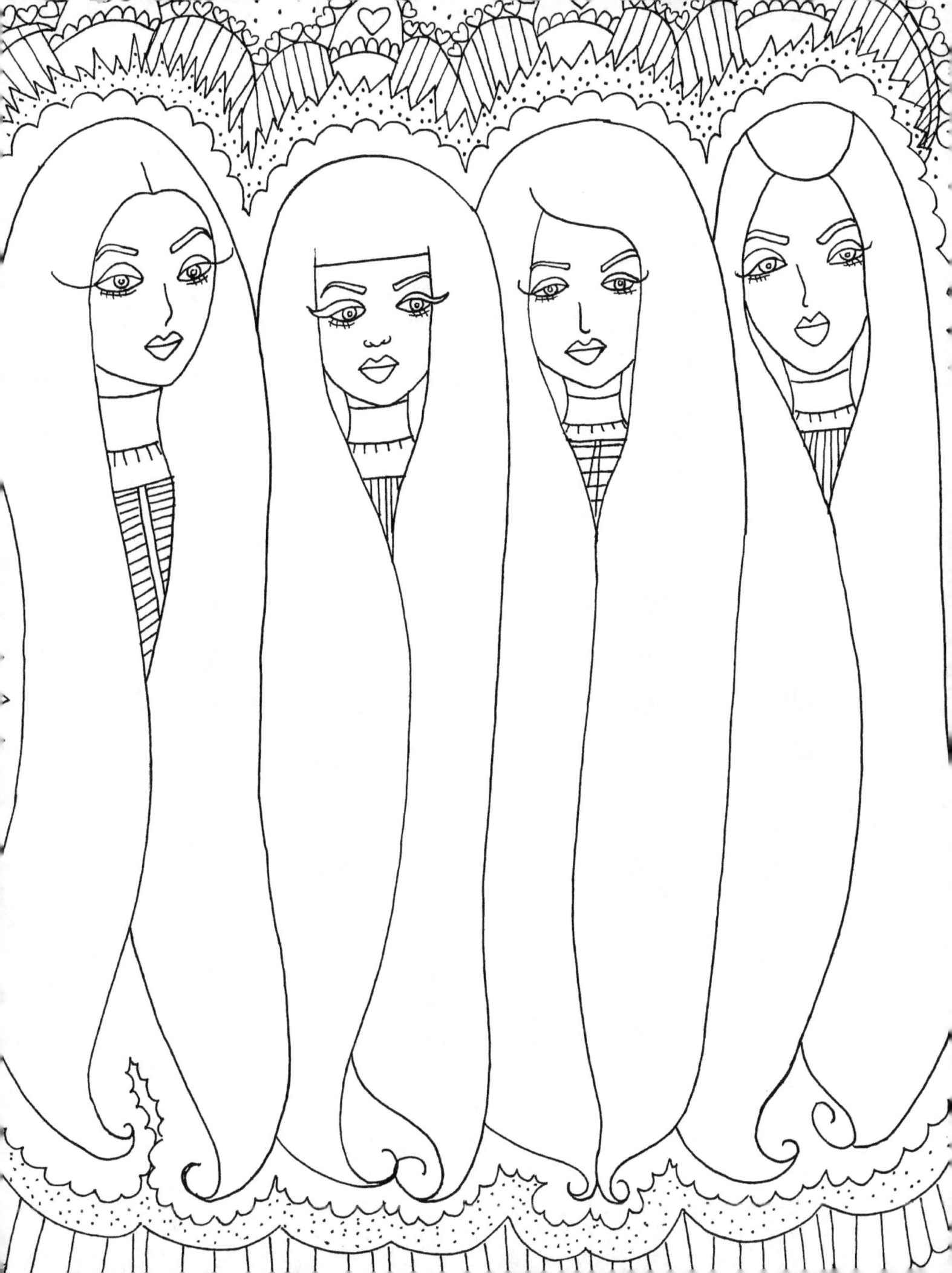

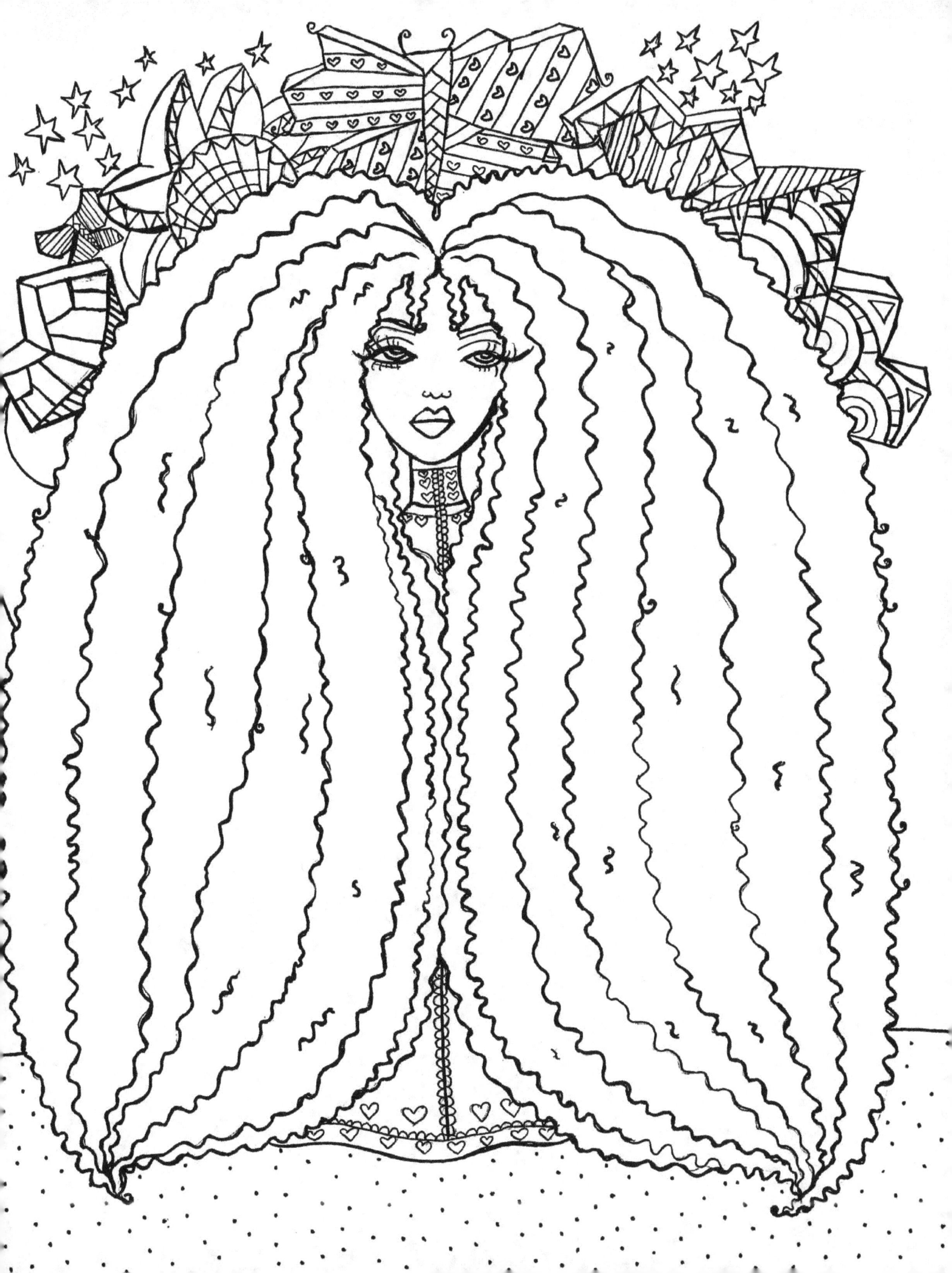

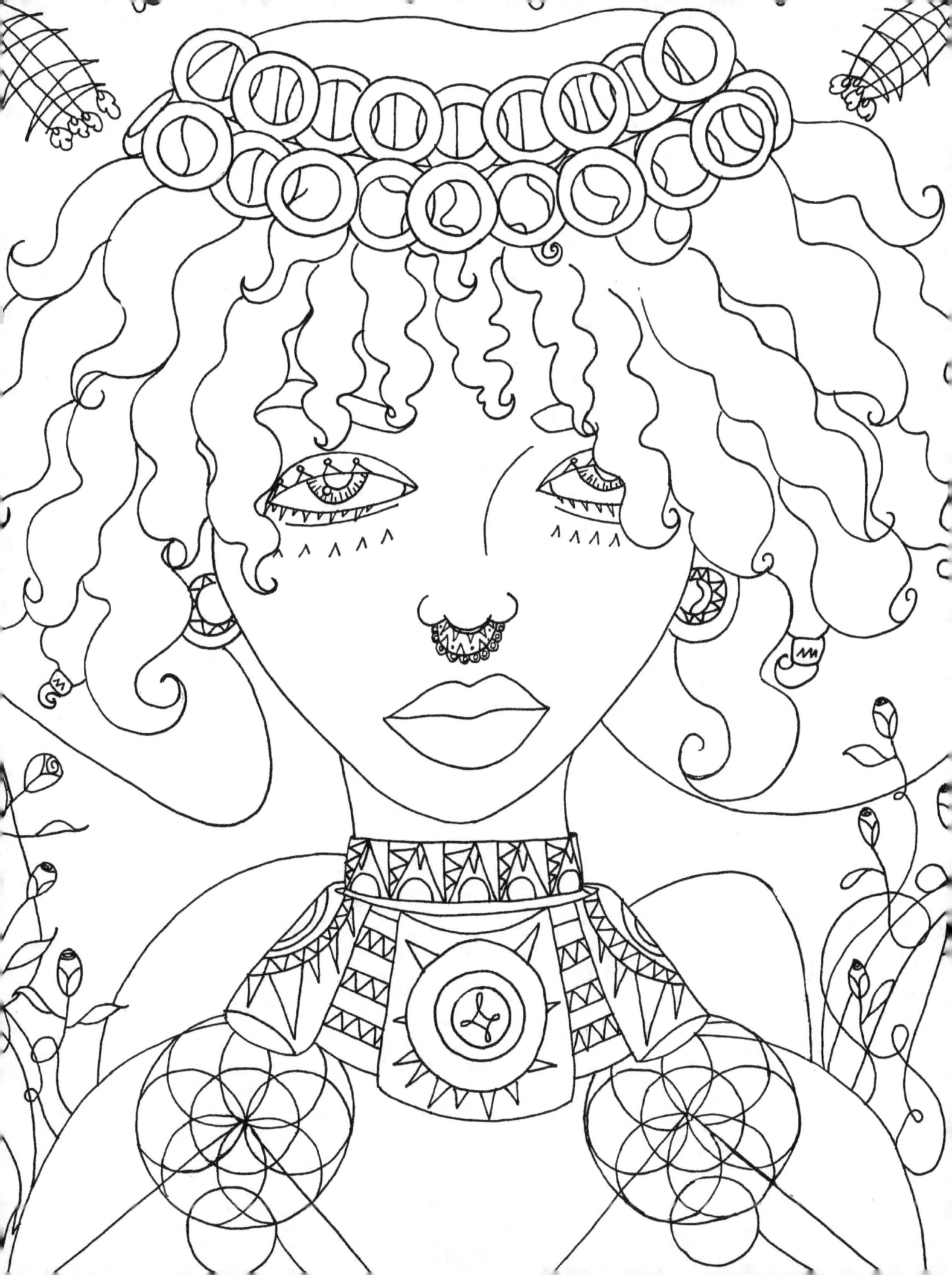

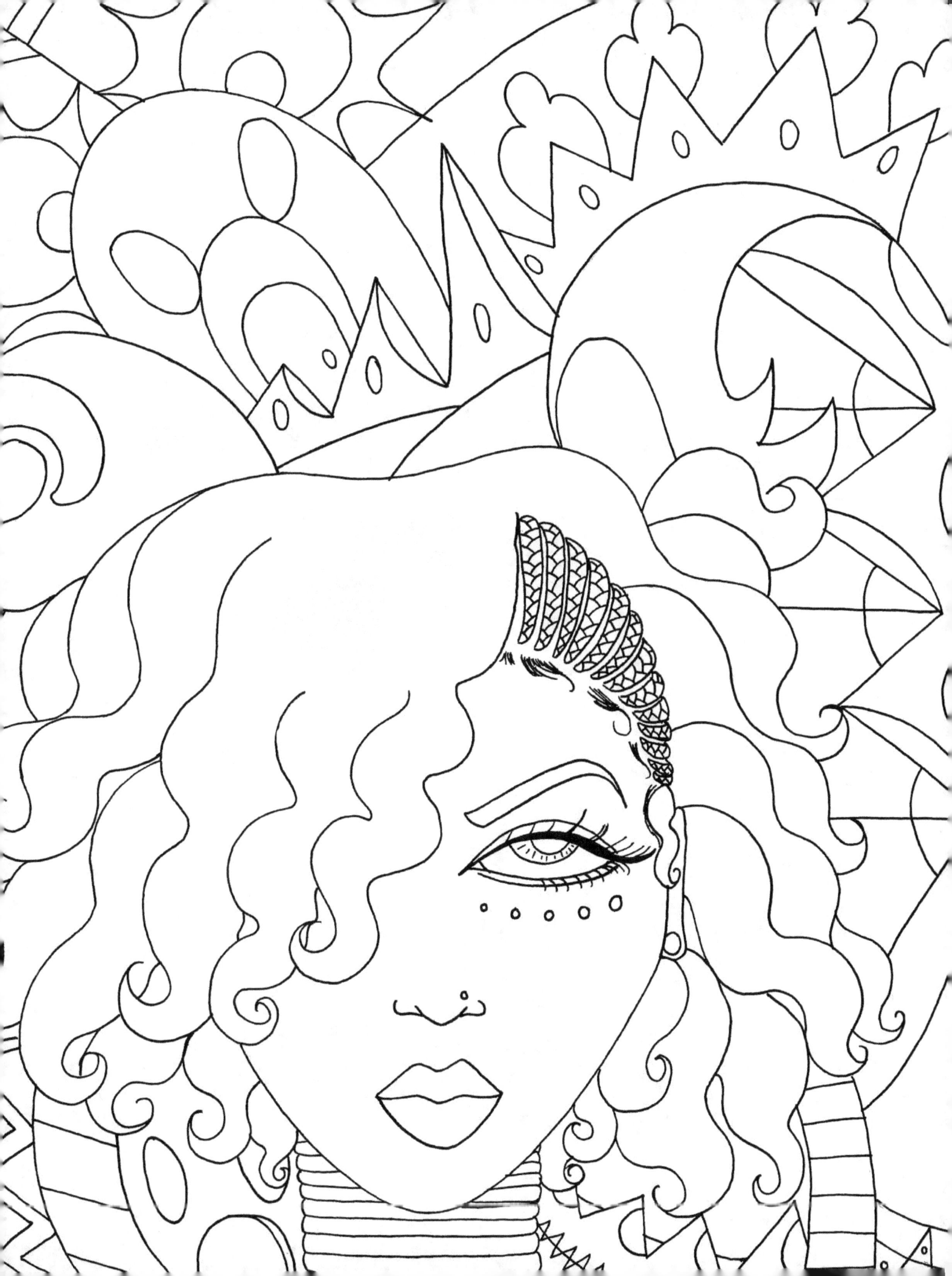

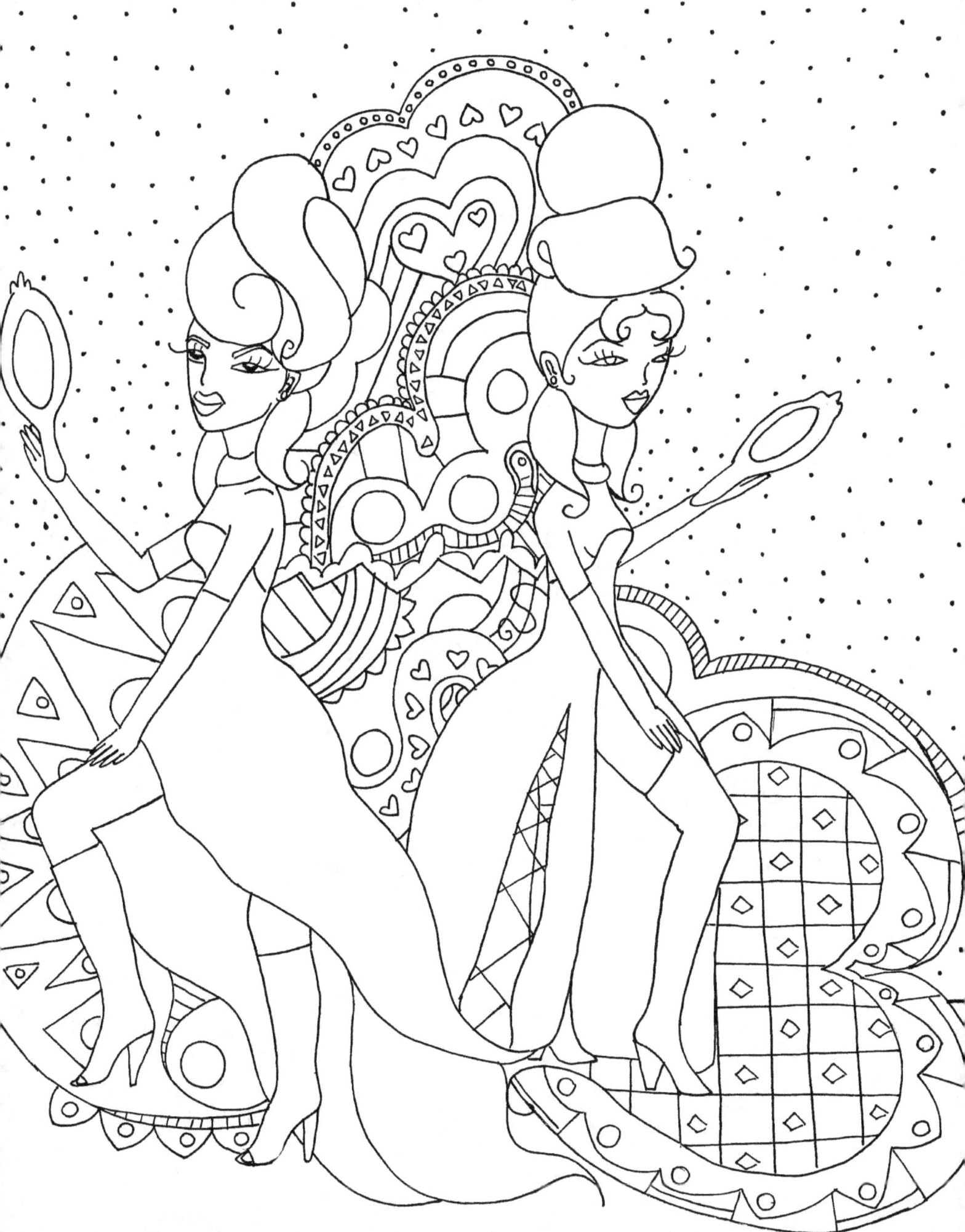

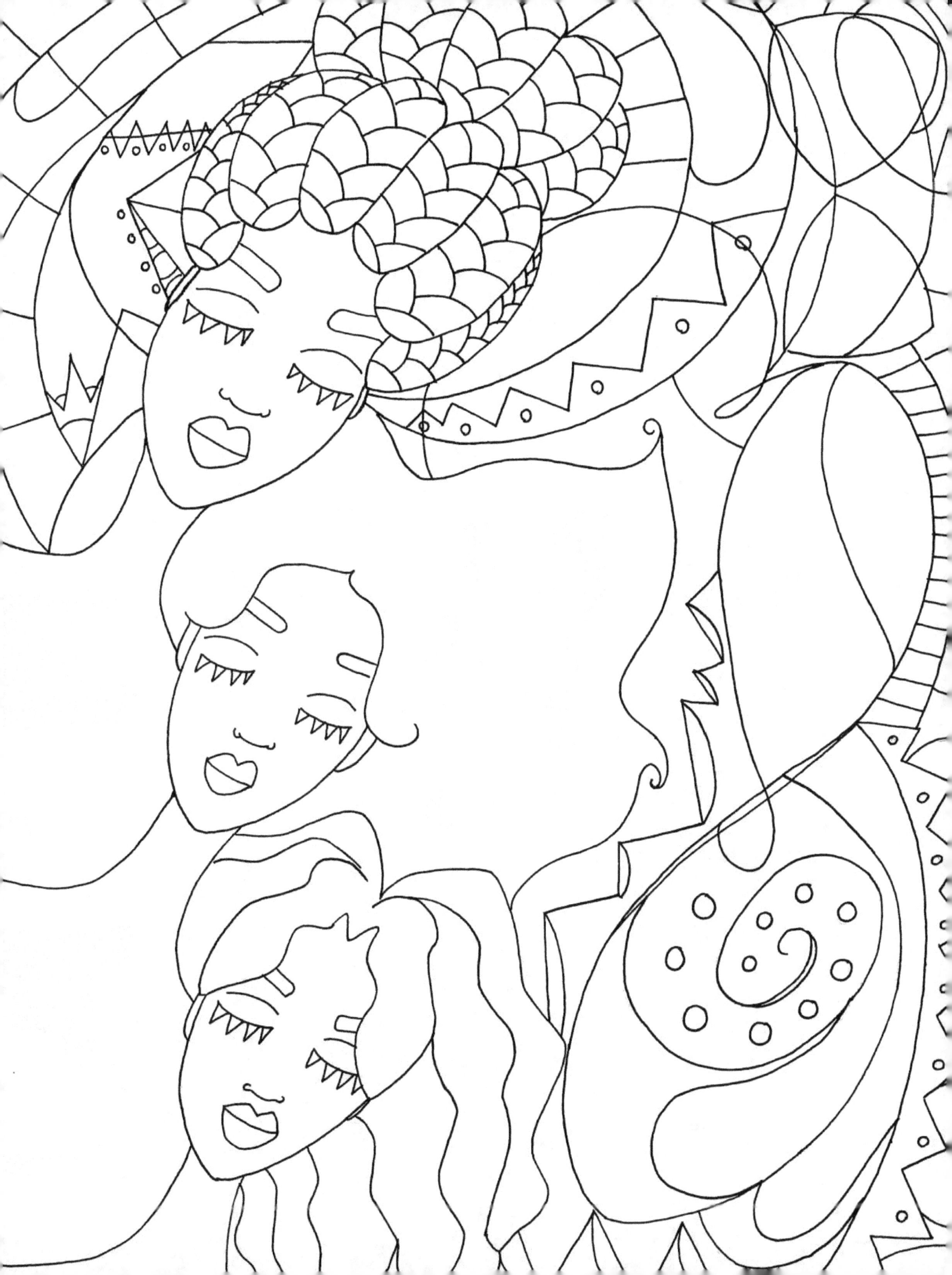

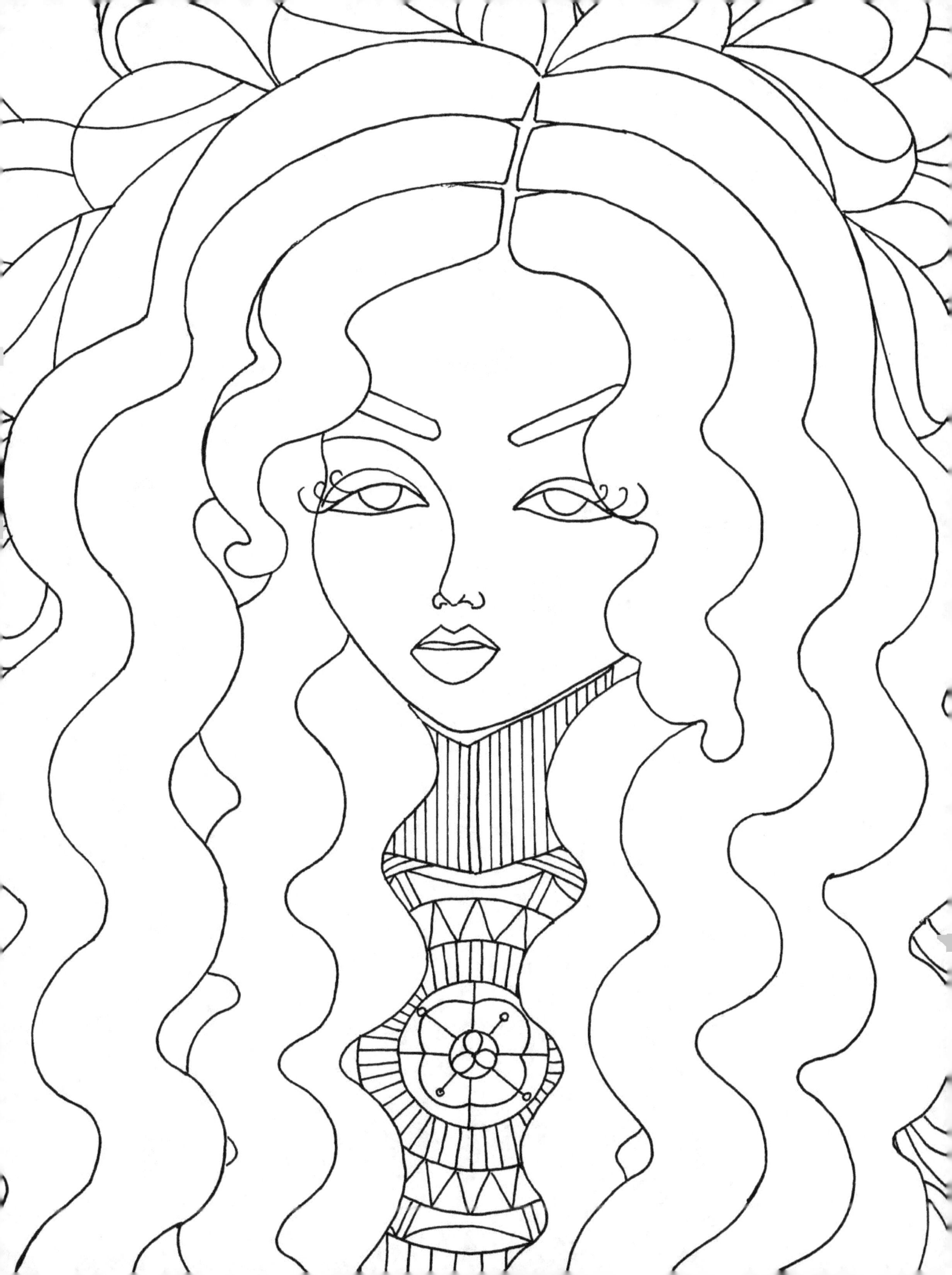

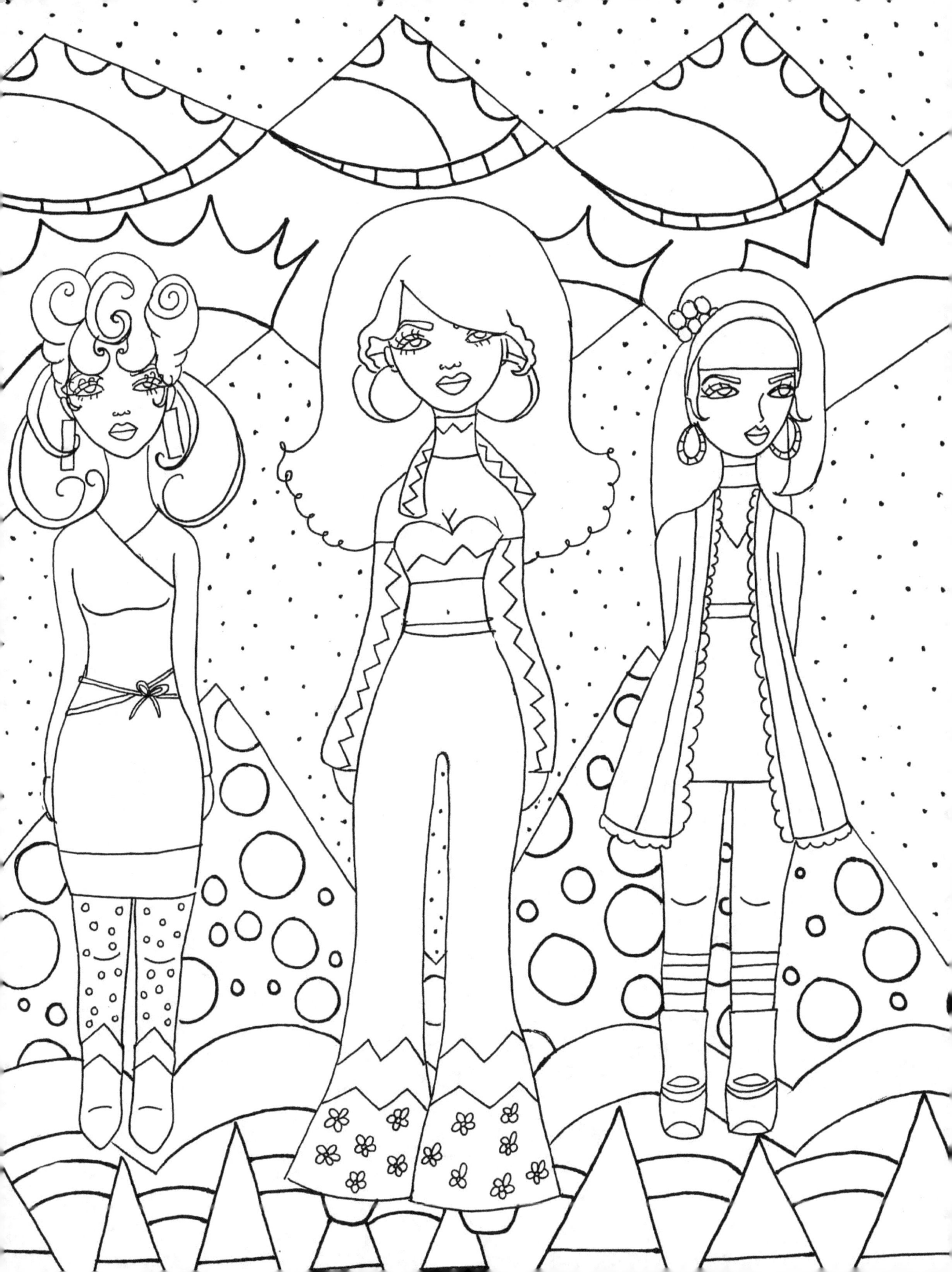

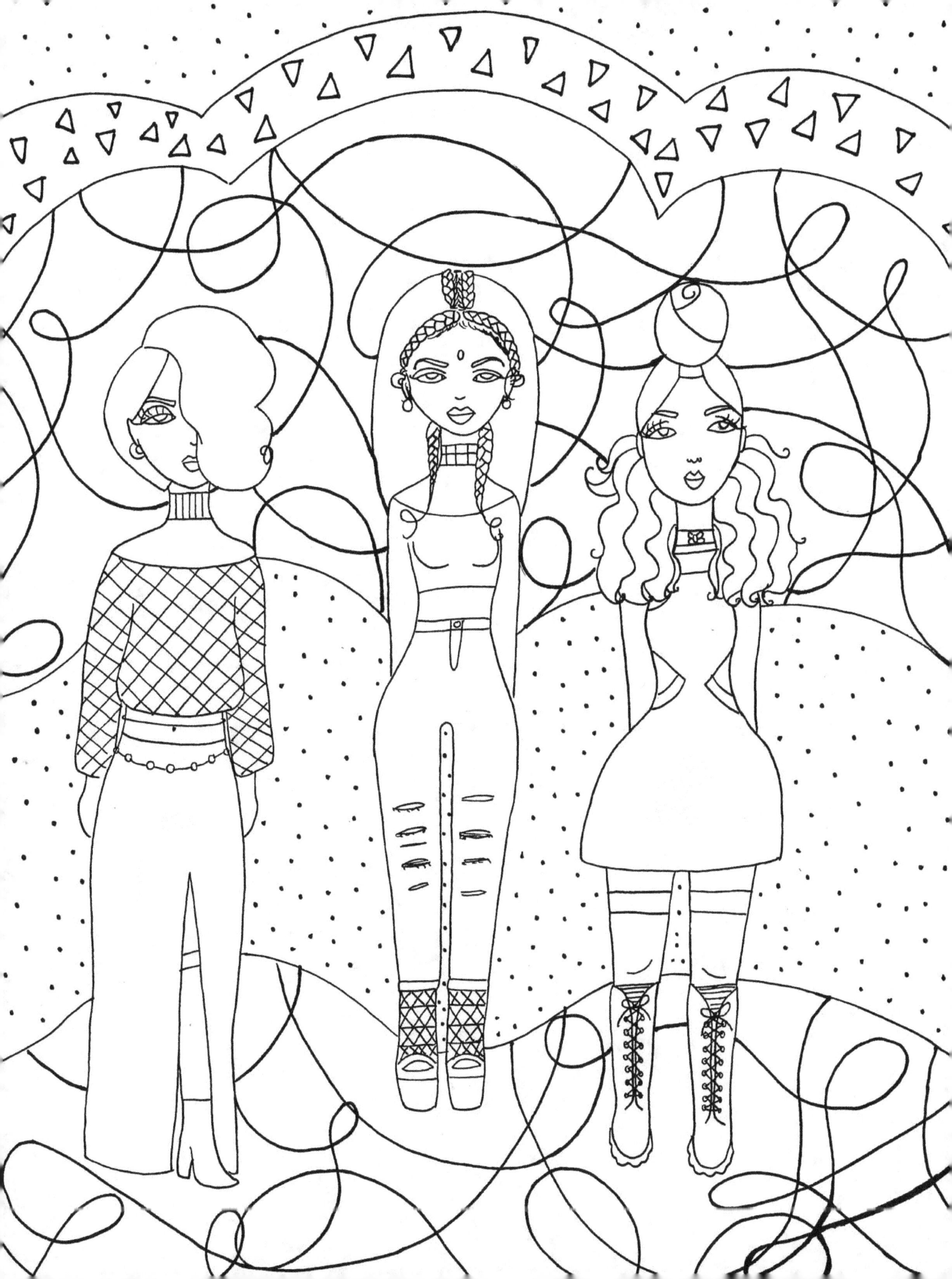

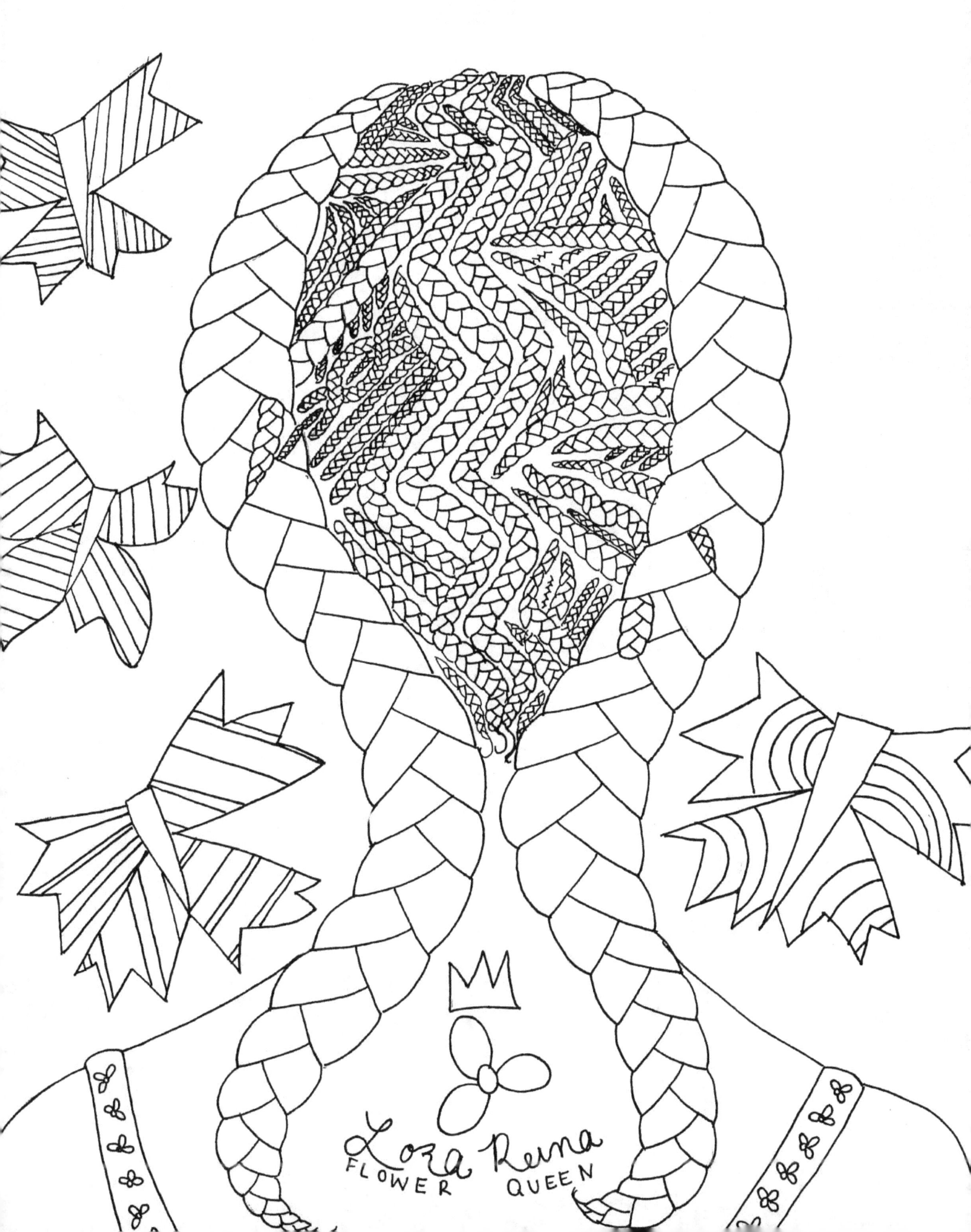

SPECIALS

✺✺✺

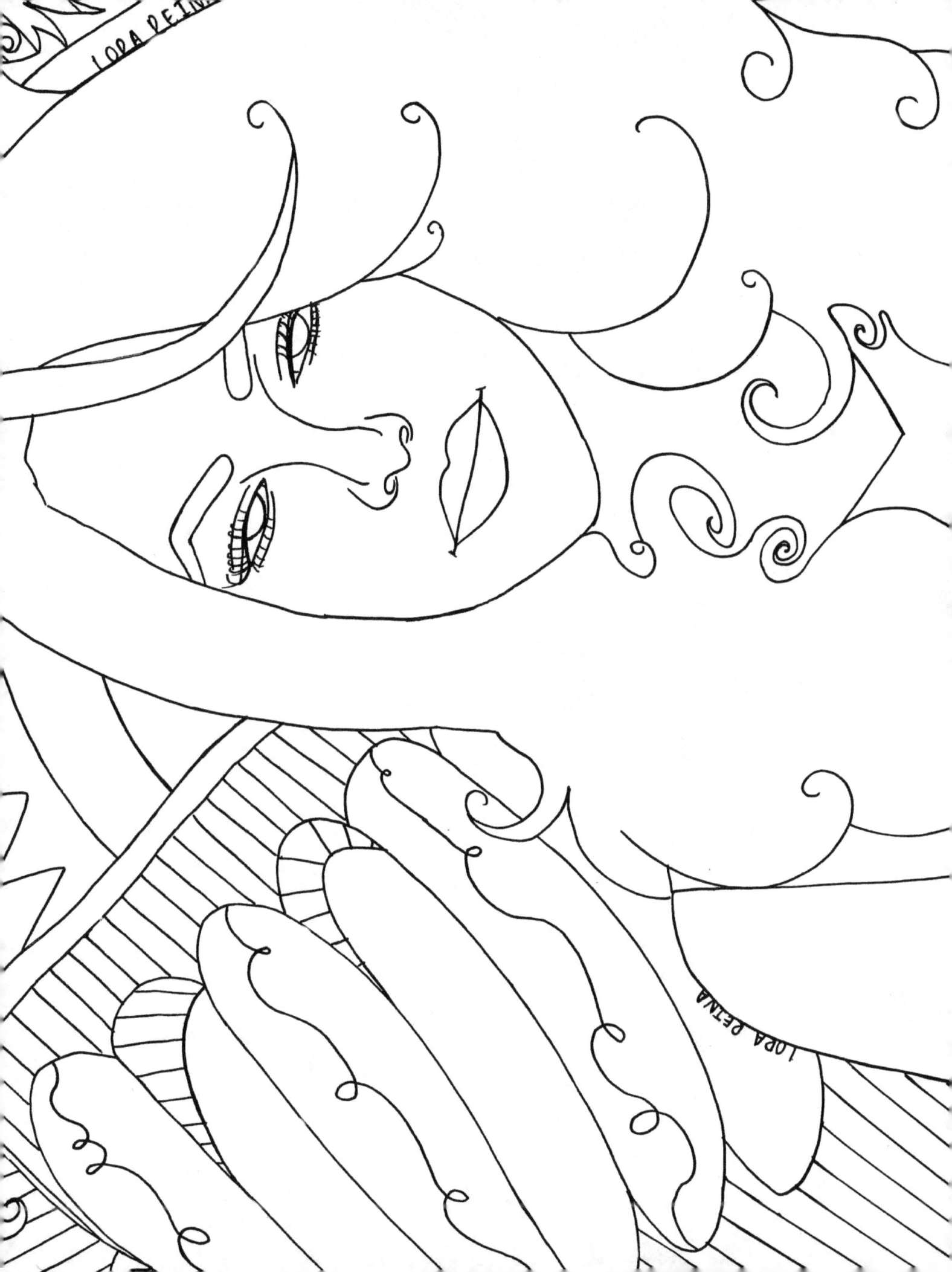

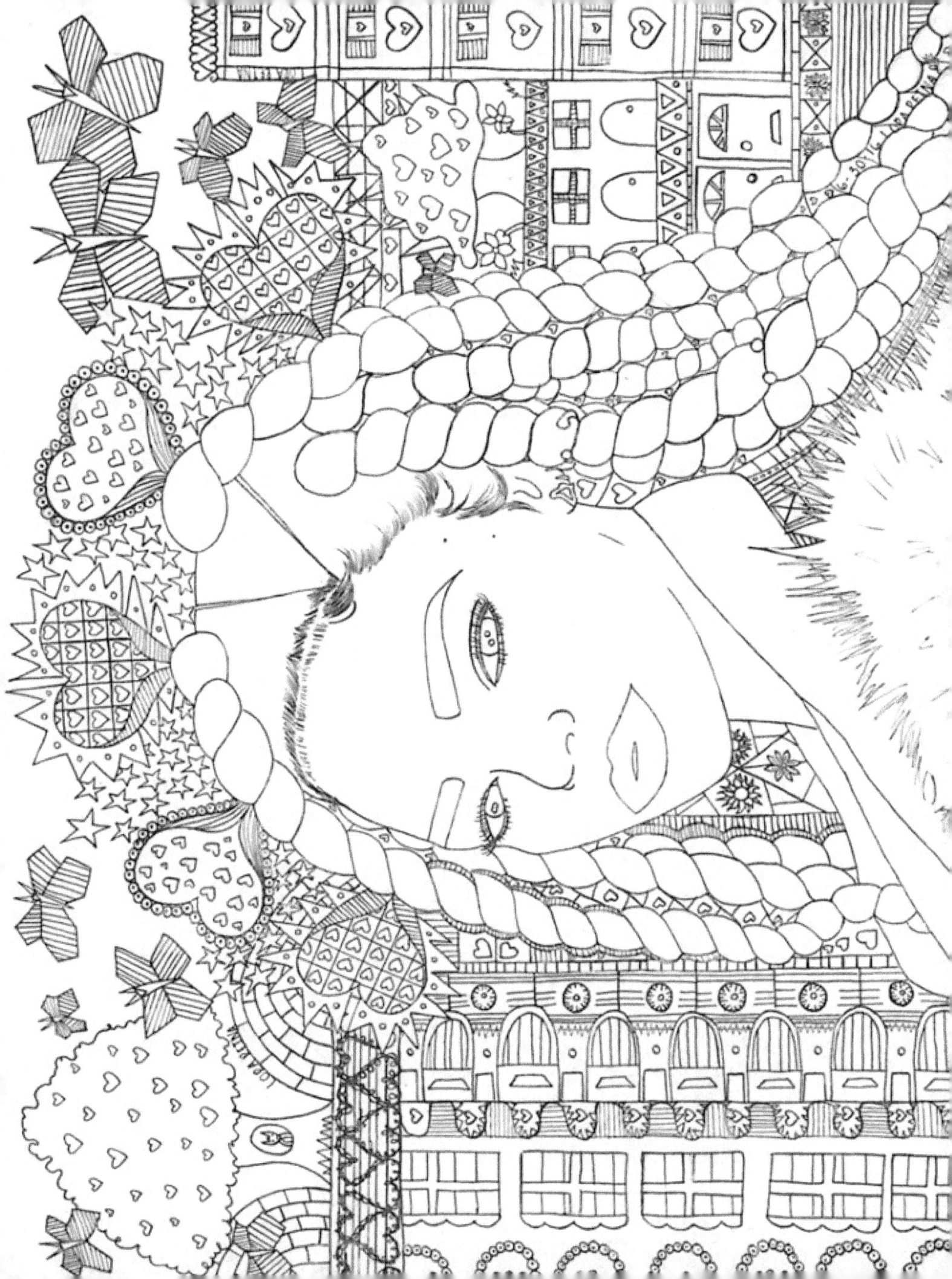

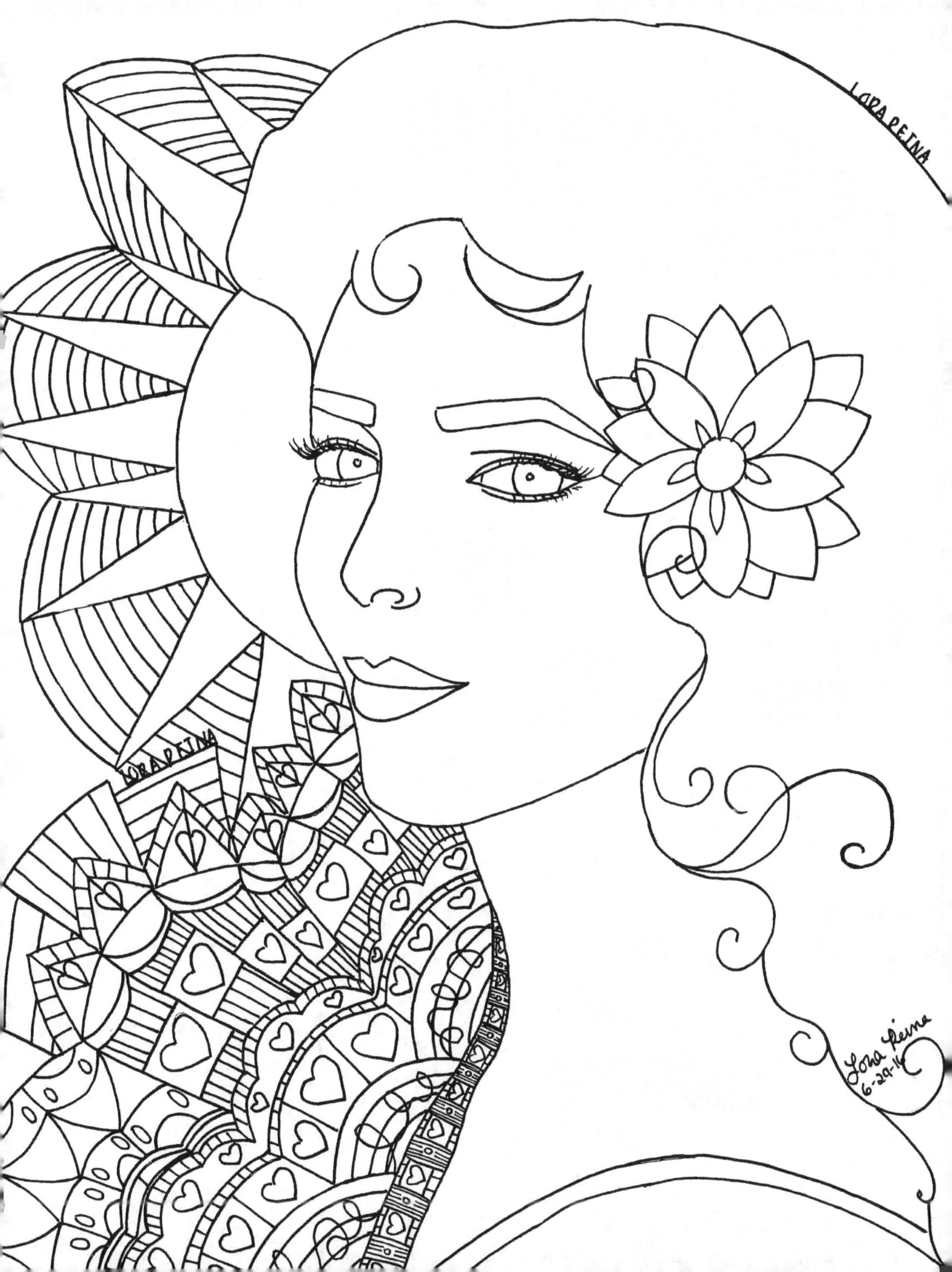

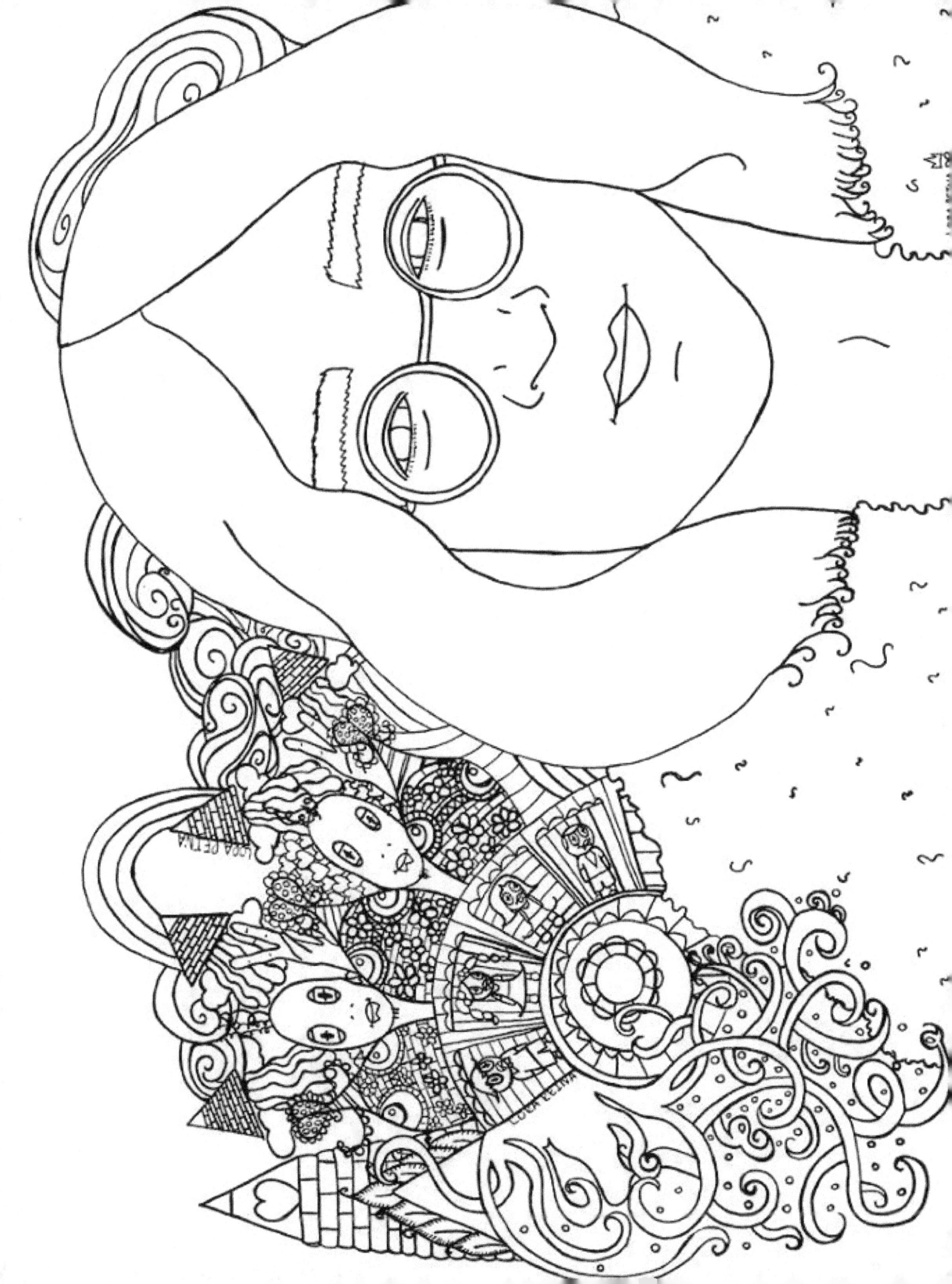

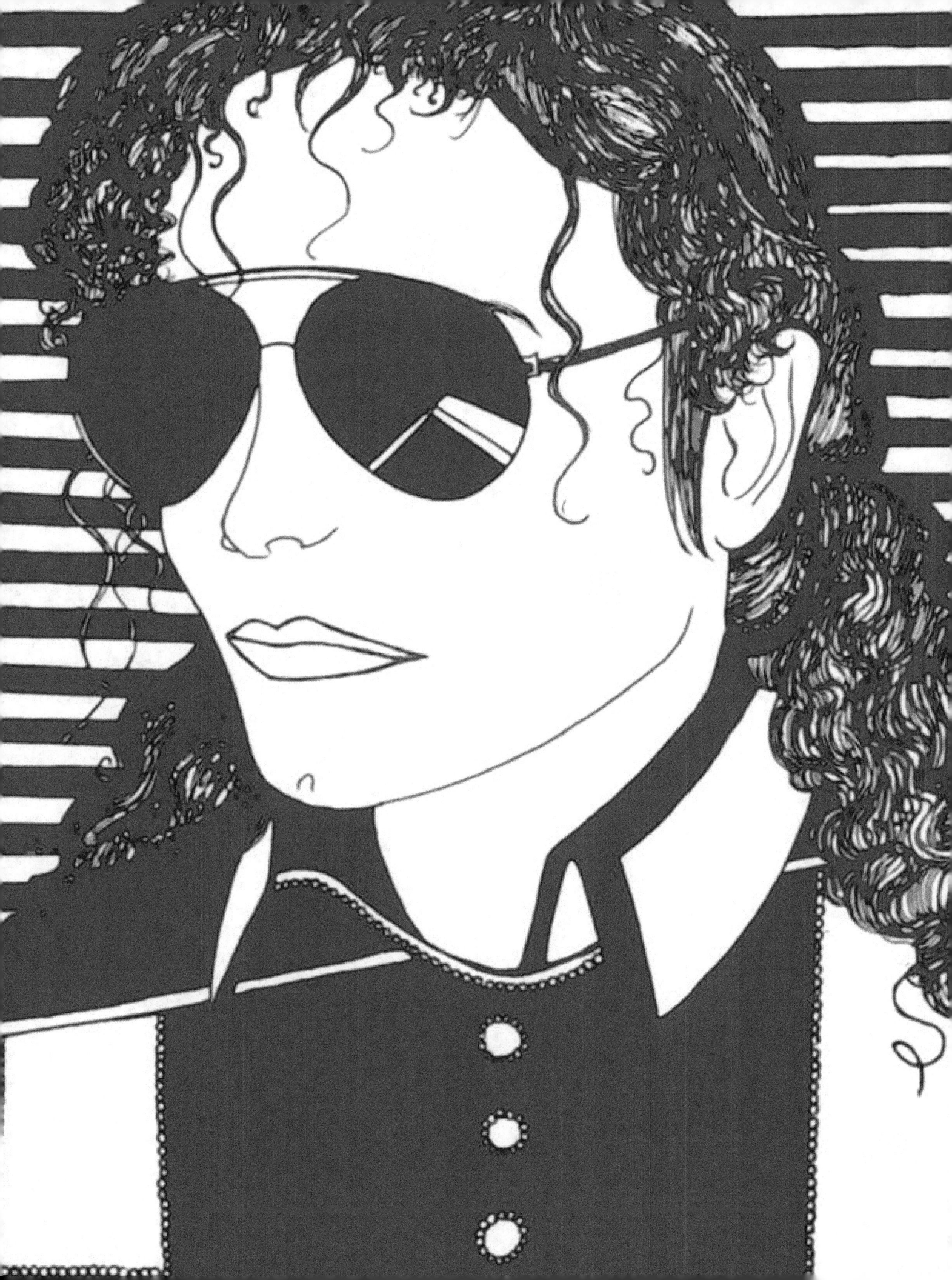

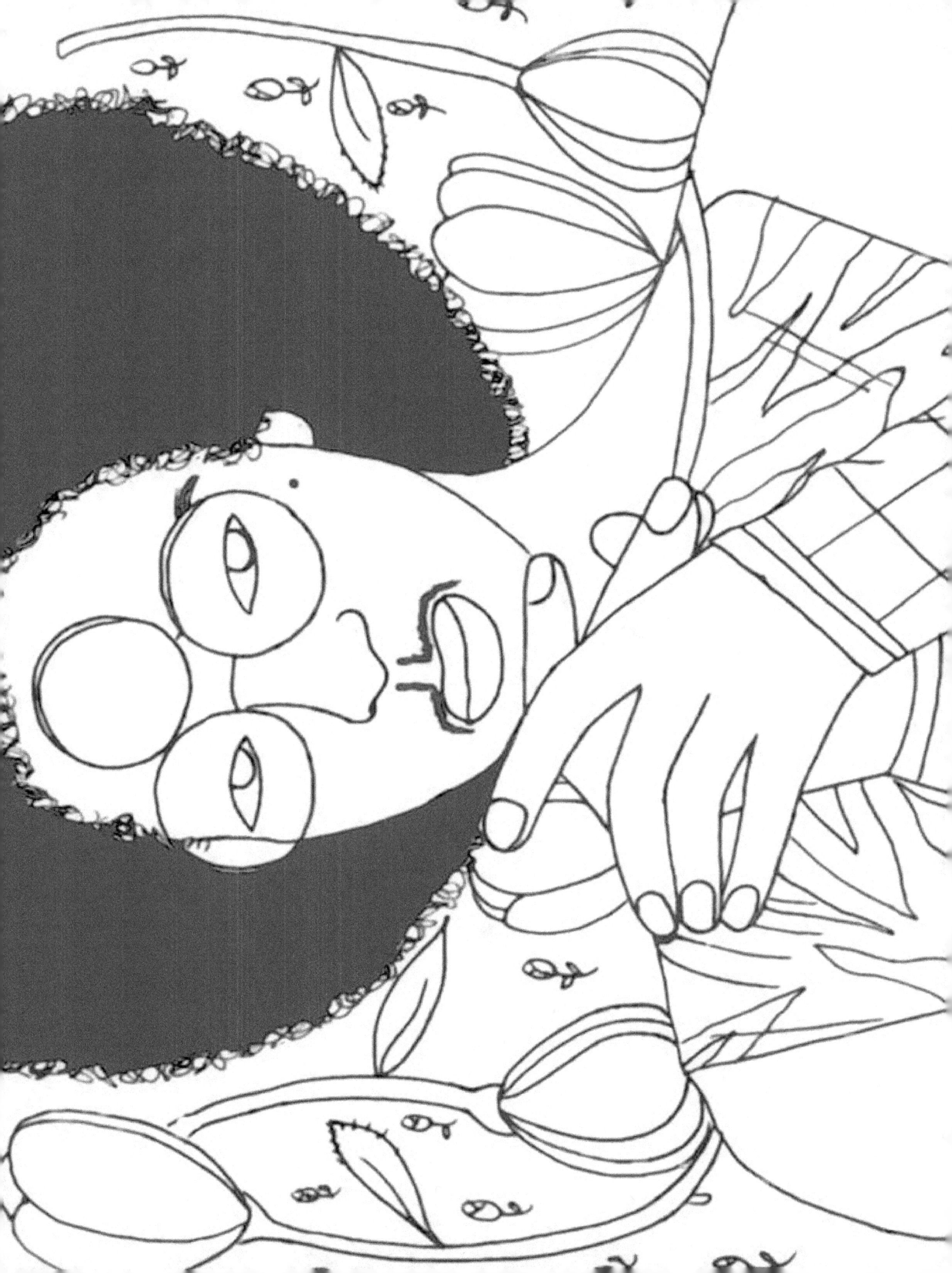

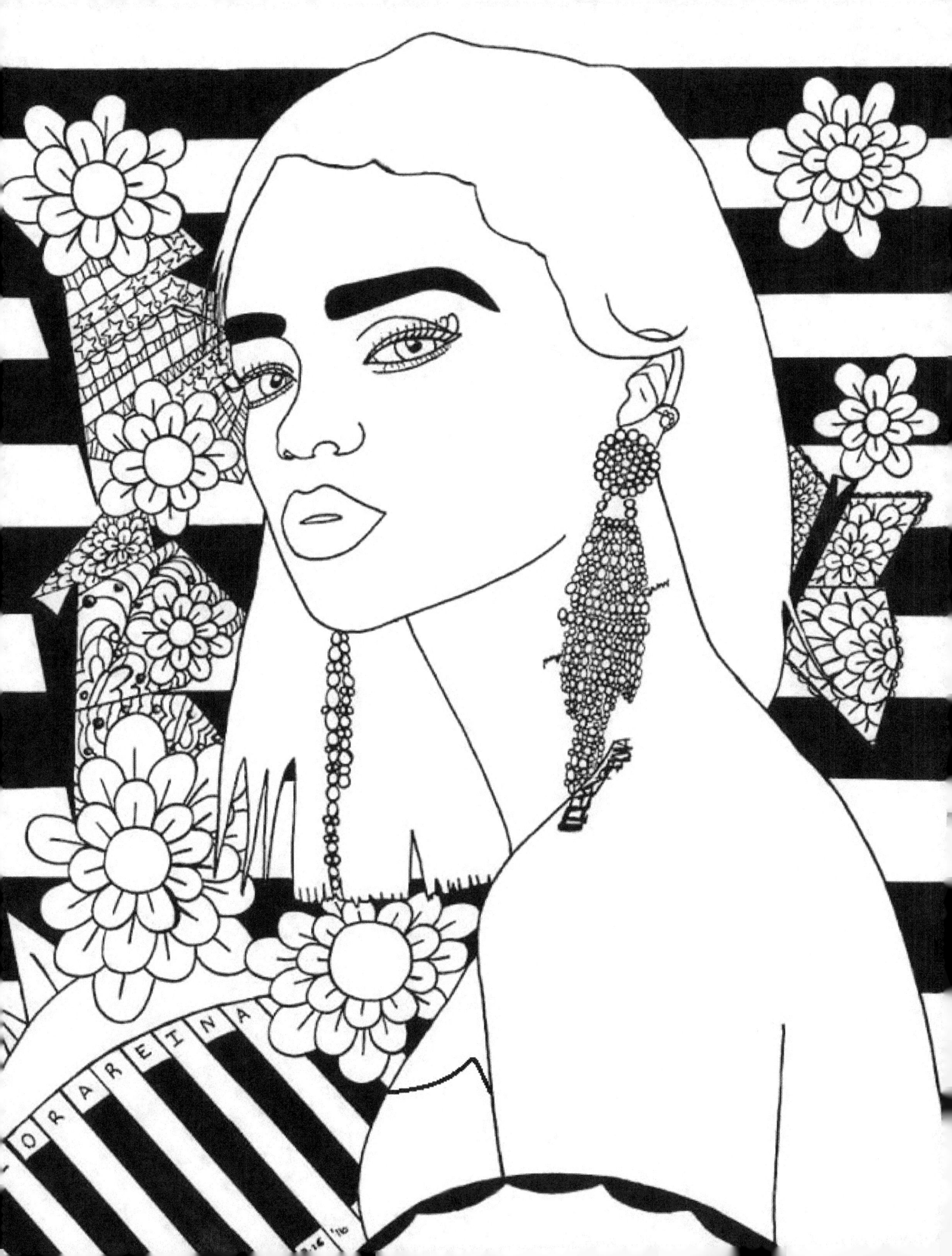

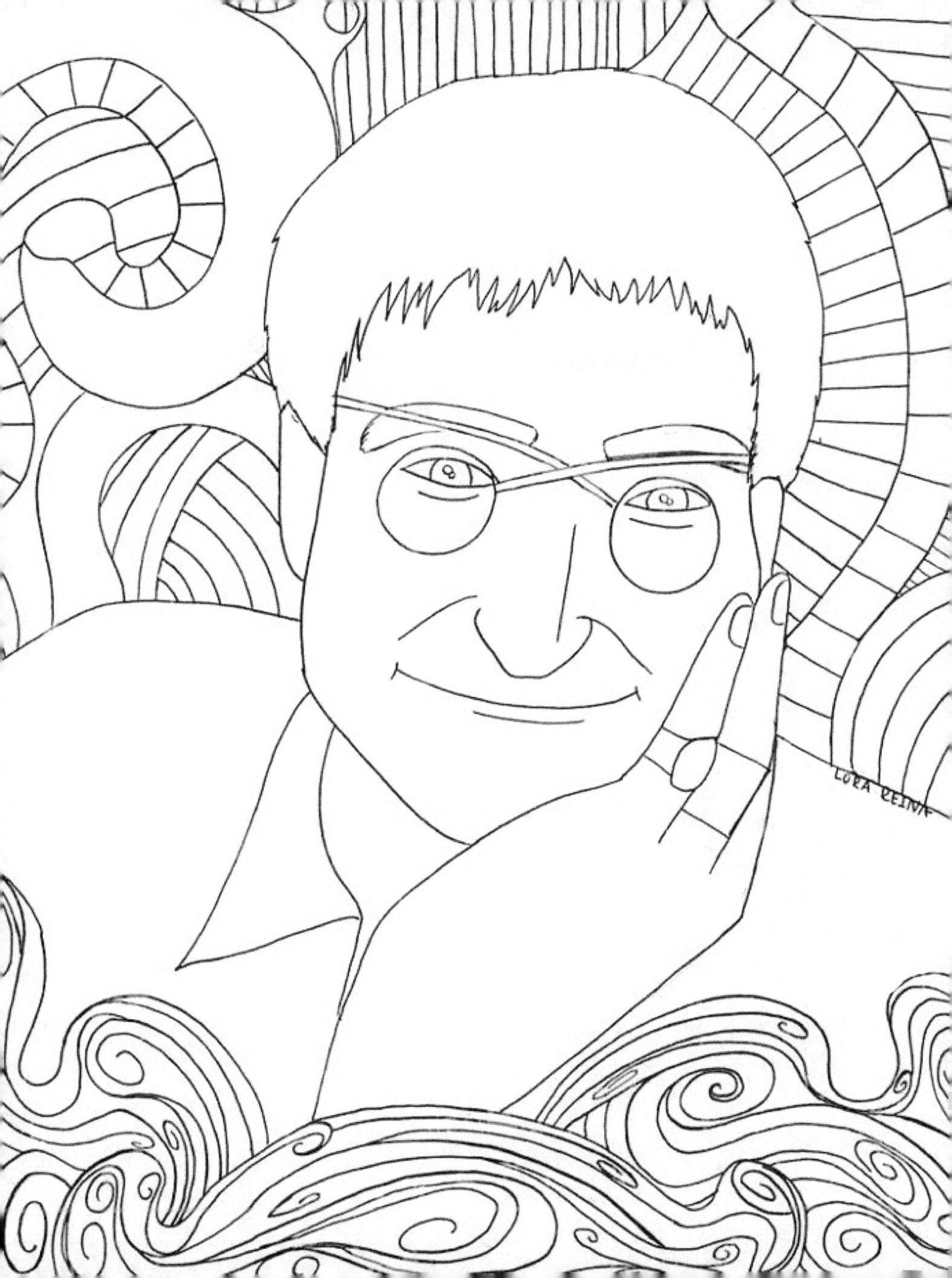

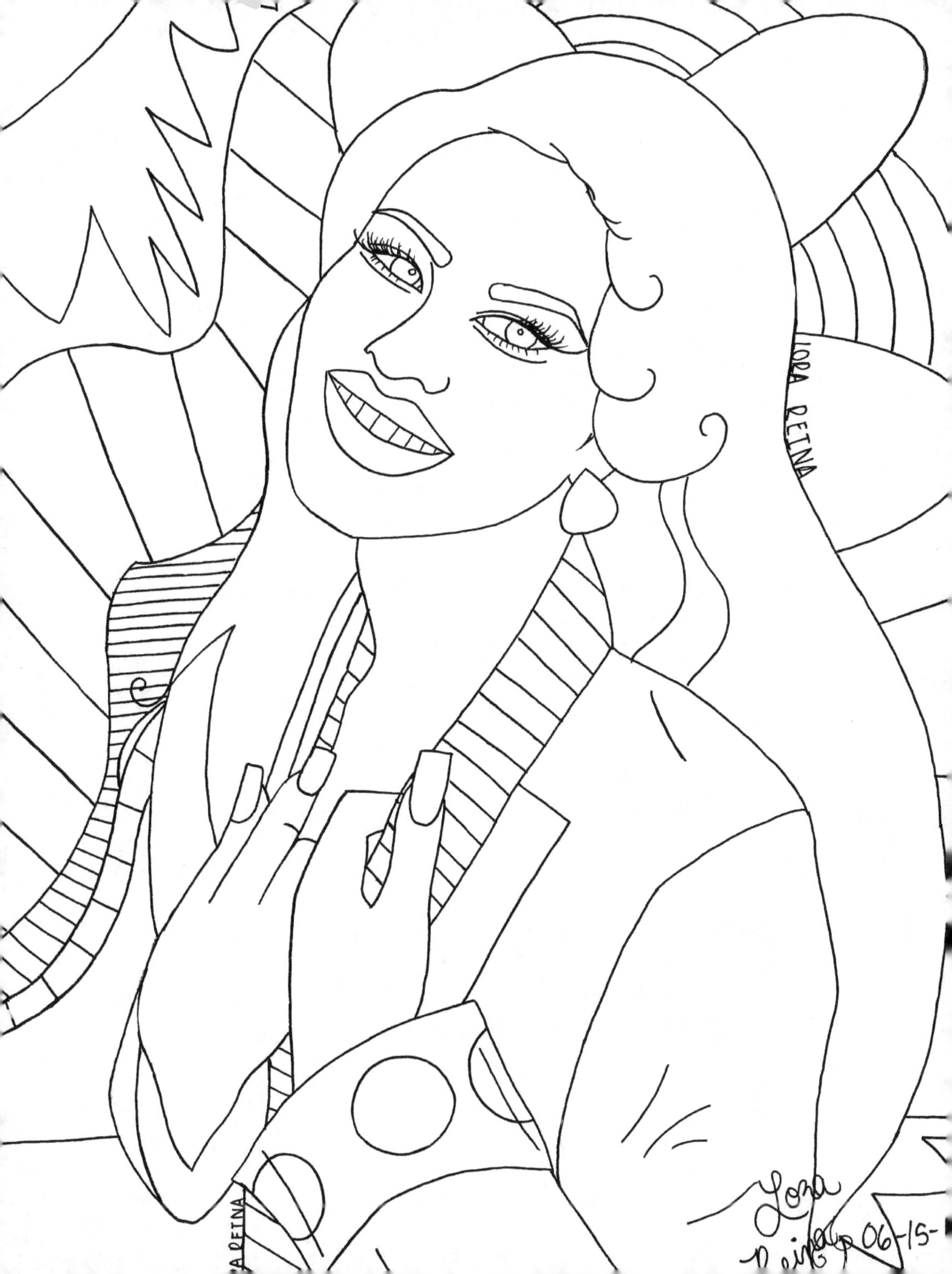

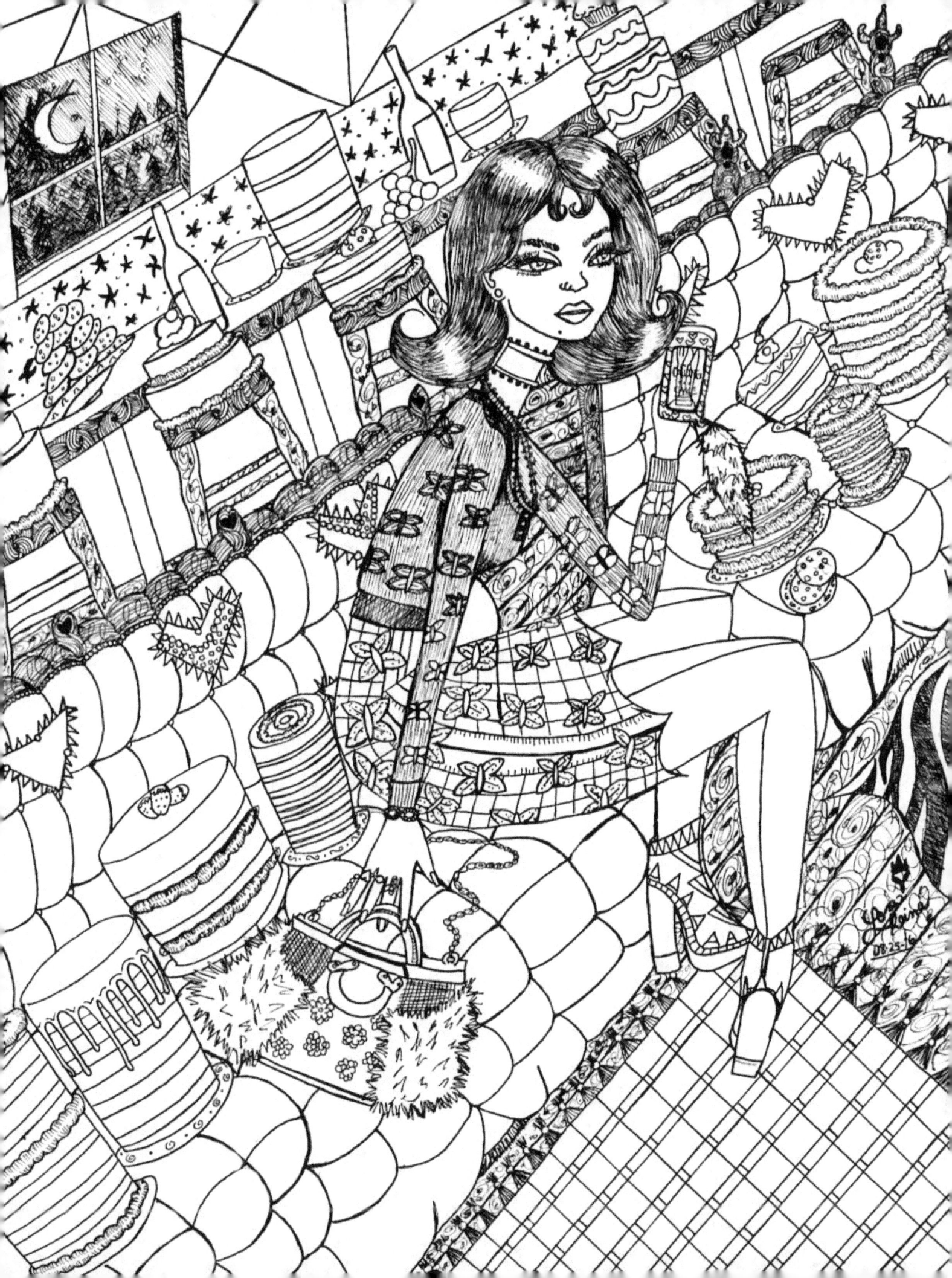

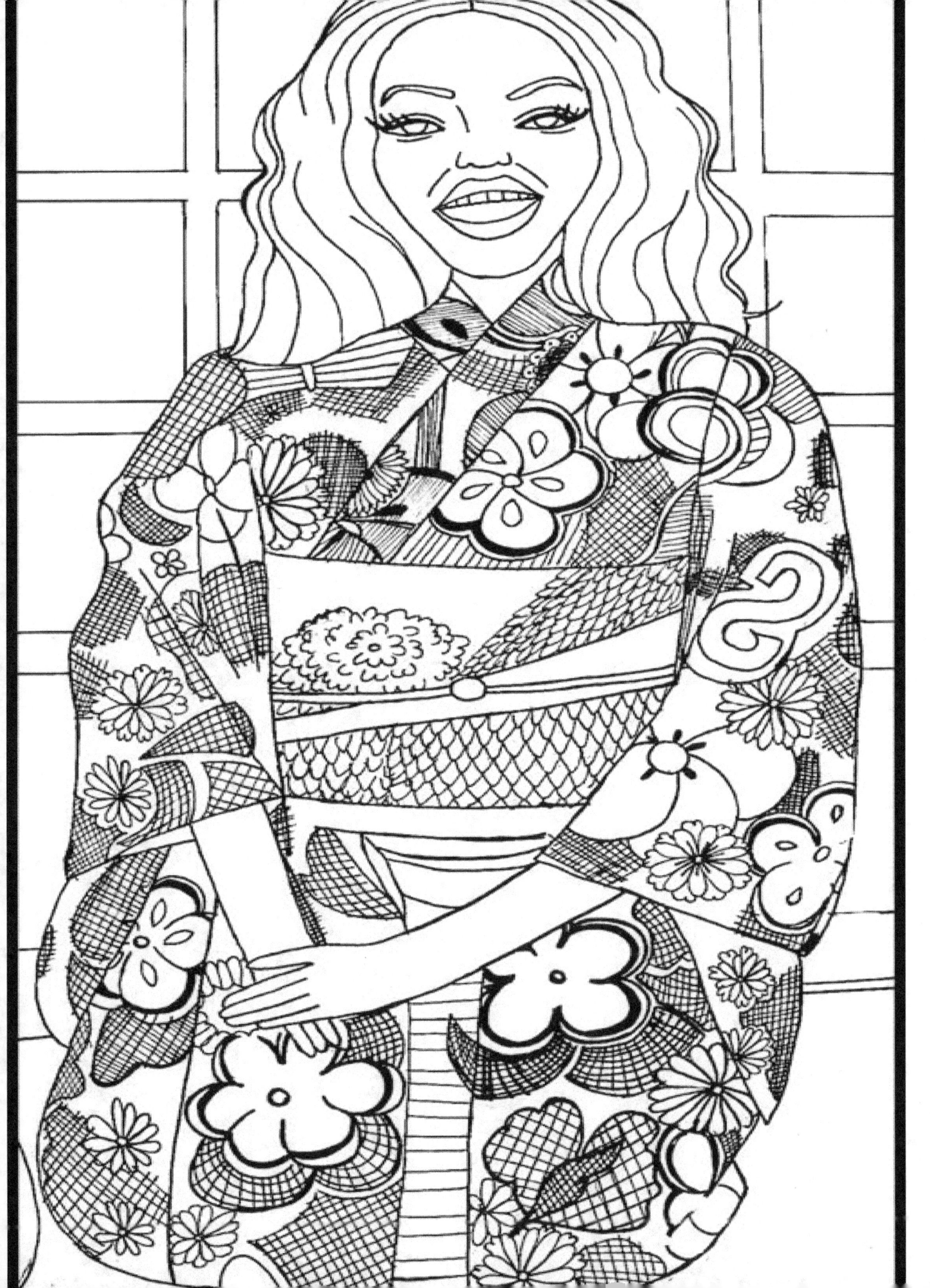

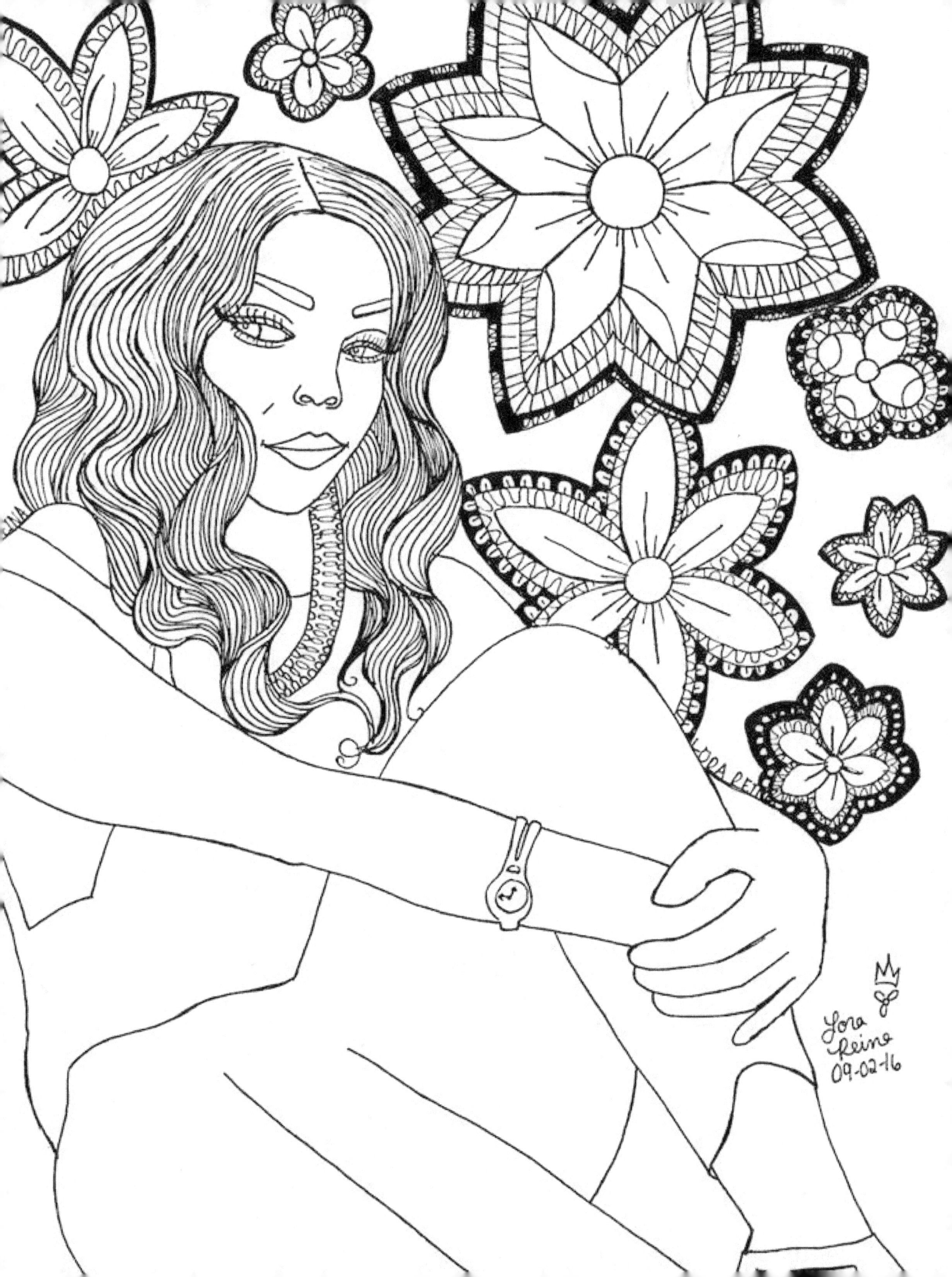

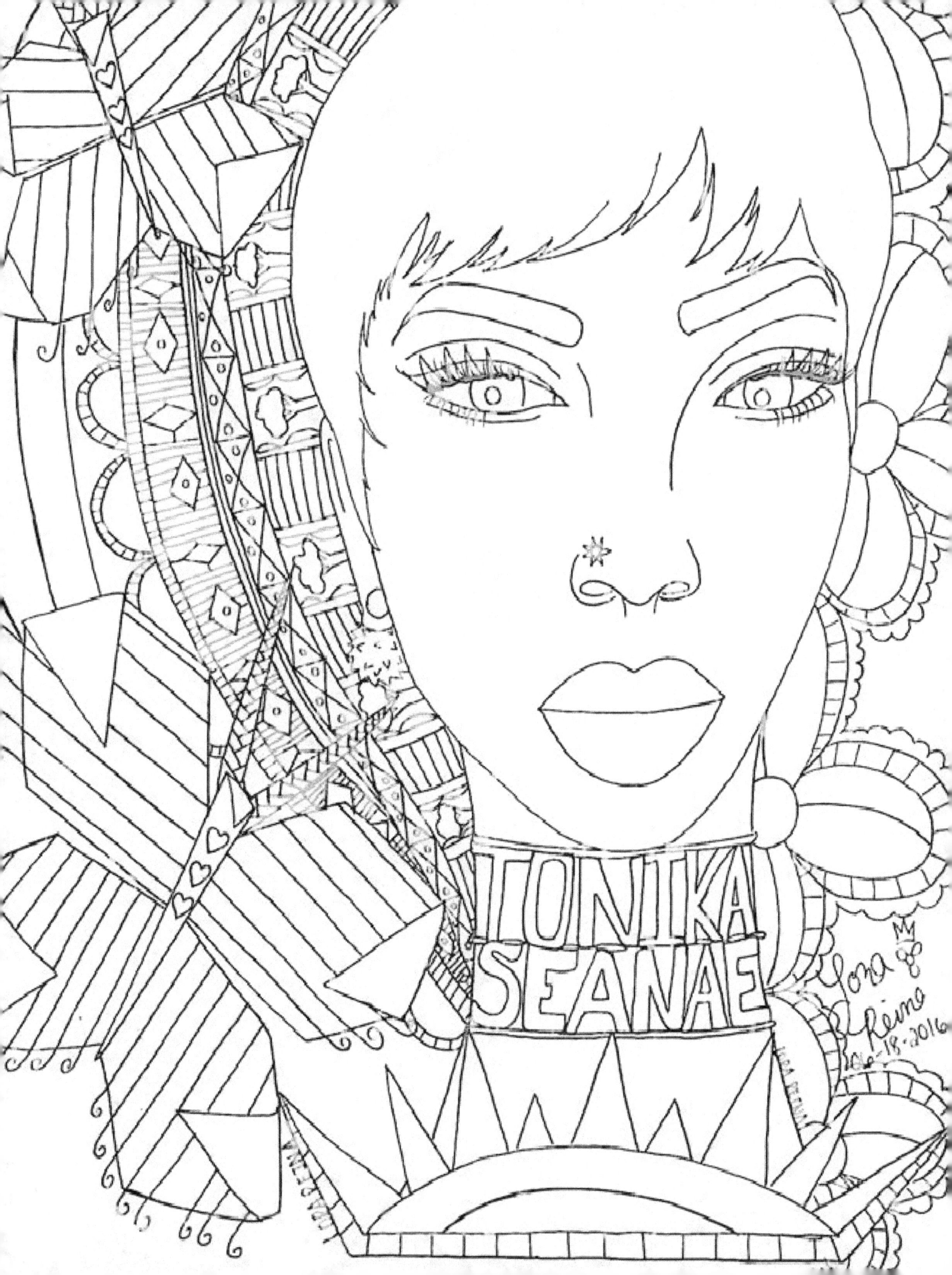

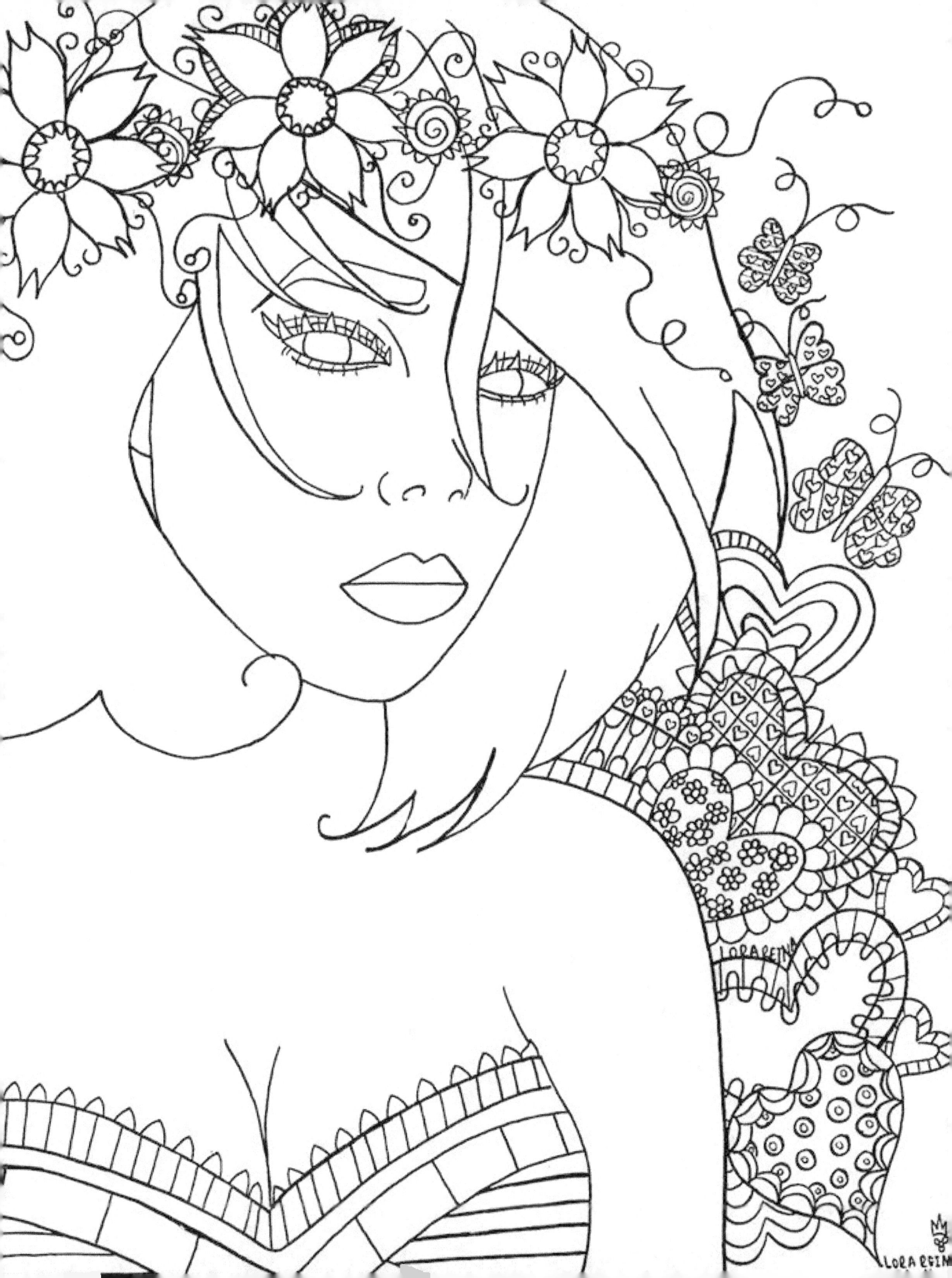

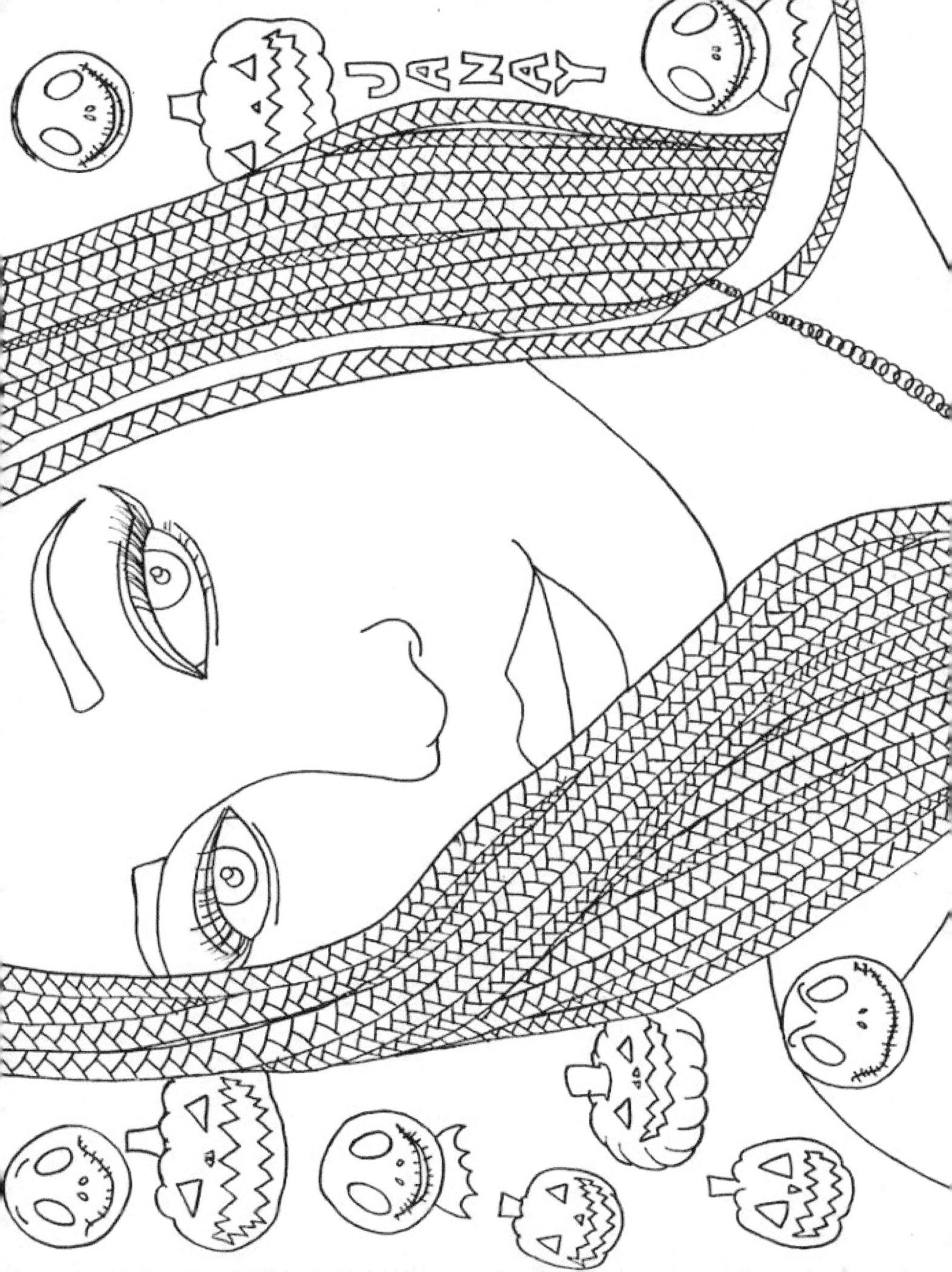

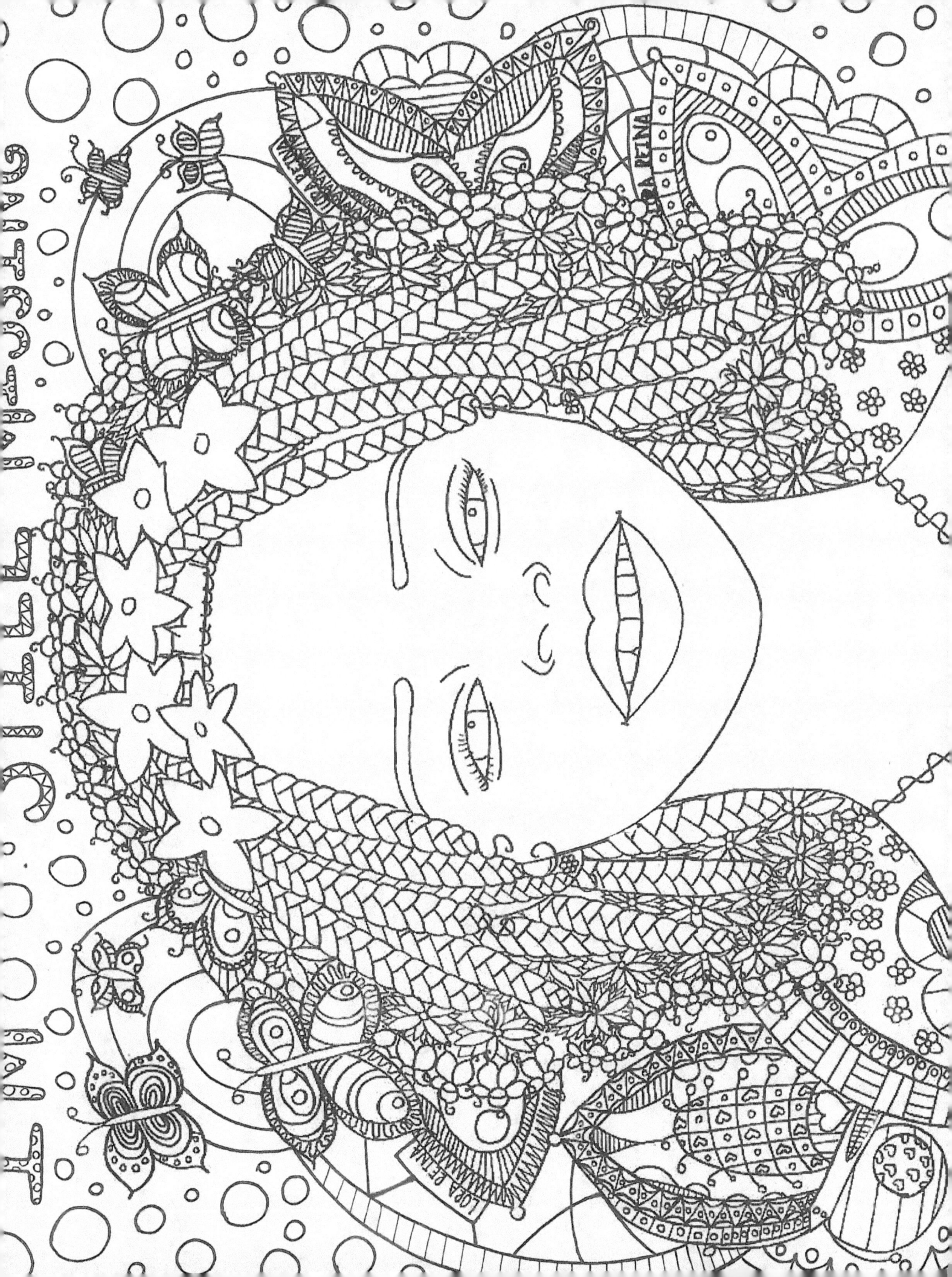

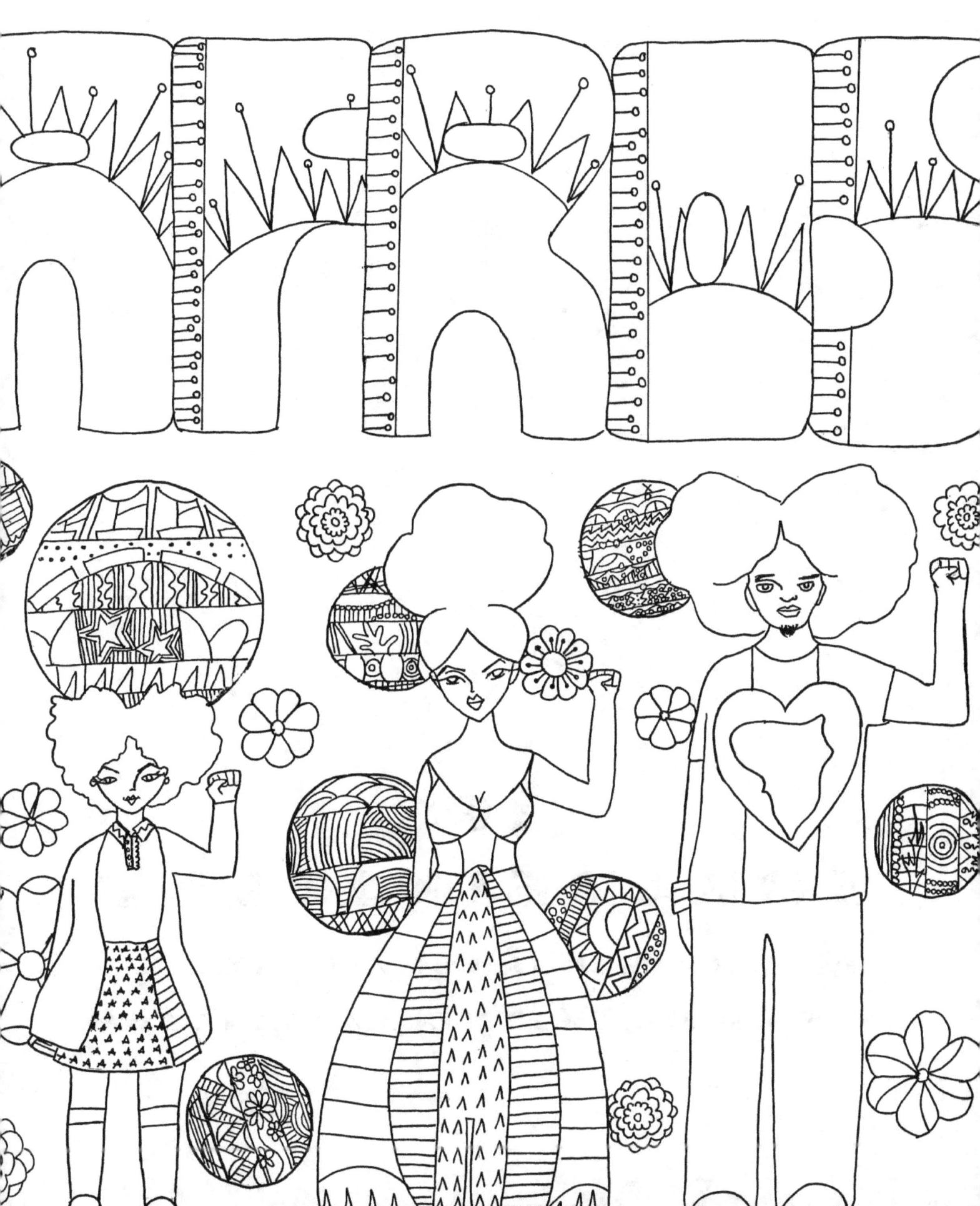

IG:
LORAREINASART

WWW.FACEBOOK.COM/LORAREINA

WWW.BLOOMWITHLORAREINA.COM

www.ingramcontent.com/pod-product-compliance
Lightning Source LLC
Chambersburg PA
CBHW081150180526
45170CB00006B/2014